IMAGES
of America

SIOUX FALLS

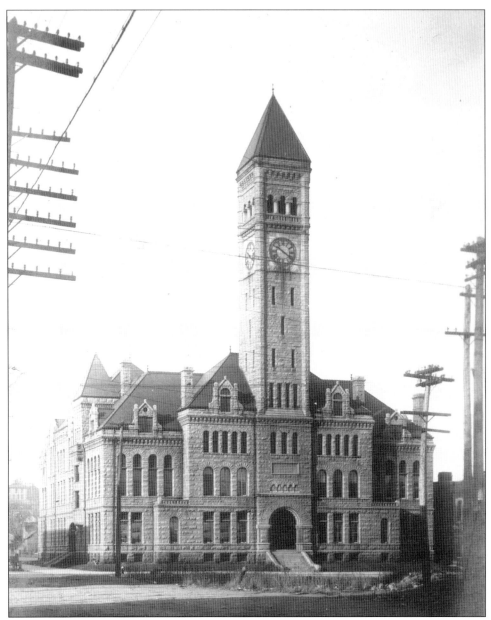

There are few buildings that can identify Sioux Falls; the Old Court House is one of them. When people have been to Sioux Falls and have seen the Old Court House, which is now a museum, they typically can identify the building with the city. As with many of Sioux Falls's most impressive building structures, the exterior of this building was built with Sioux quartzite, a native stone quarried from within Sioux Falls. Not only did Sioux quartzite create beautiful-looking buildings in the area as well as other major cities, the impressive stone created the formation of the falls of the Sioux River, the namesake of Sioux Falls.

On the cover: The picture on the front cover shows the northwest corner of Phillips Avenue and Ninth Street, as it looked around 1888. The famous Cataract Hotel had three different buildings on this location and was in business on this corner for 101 years. (Author's collection.)

IMAGES
of America

SIOUX FALLS

Dr. Rick D. Odland

ARCADIA
PUBLISHING

Published by Arcadia Publishing
Charleston SC, Chicago IL, Portsmouth NH, San Francisco CA

Printed in the United States of America

Library of Congress Catalog Card Number: 2006937458

For all general information contact Arcadia Publishing at:
Telephone 843-853-2070
Fax 843-853-0044
E-mail sales@arcadiapublishing.com
For customer service and orders:
Toll-Free 1-888-313-2665

Visit us on the Internet at www.arcadiapublishing.com

This book is dedicated to my wonderful wife, Amy, who has shown unconditional love and support with this book project. Not only has she put up with the piles of pictures, postcards, books, and other Sioux Falls ephemera, but she has been enthused about this project in a way only a wife could. Also, thank you to my children, Alex and Rebekah. Yes I am your dad and not just the stranger who has come home from work lately and sat down at the computer to type and sift through postcards. For all this, I say thank you and I love you.

CONTENTS

Acknowledgments 6

Introduction 7

1. From a Village to a City 9

2. Schools 15

3. Churches 29

4. Hospitals 41

5. Railroad Depots 49

6. Government Buildings 53

7. Streets, Buildings, and Miscellaneous 63

8. Parks 119

Sioux Falls Village Presidents and City Mayors, 1877–Present 127

ACKNOWLEDGMENTS

I have been working on writing this book for a long time. I have met many neat people that have seen many years in this great city. The people I visited with spoke so highly of this great city and were very willing to allow me to share their pictures and information. I want to give a special thank you to Mark Thorstenson for his review of the material for historical accuracy. Thank you to the Sioux Falls Historians I worked with: Robert Kolbe, Mike Wiese, Janie Cloud, Carol Mashek, and Rick Castardo. Thank you also to those that provided pictures and information for this book: Ed Monson; Hugh Dodson; Rev. Richard Vinson Dean; Pam Alexander; Randy Haack; Todd Schuldt; Amy Blum; Judy Clauson Krell; Greg Fritz; Curt Mundt; Jon Brown; Carol Knapp; Elvin Thomsen; Gerry White; Dr. Bill and Twyla Smith; Bev Chase; Ed Leavitt; Debbie McClure; Siouxland Heritage Museums, Sioux Falls, South Dakota; University of Sioux Falls Archives Norman B. Mears Library; Eastside Presbyterian Church; and First Congregational Church.

I also want to thank Kris Millikan for all of his genius help when the computer did not want to work correctly. Also I say thank you to Pat Marso, Hollie St. Pierre, Derek Odland, and Katie Odland for all of their help with this project.

INTRODUCTION

It is my goal for this book to be entertaining and educating at the same time. My hope is that this book will bring together a common bond between parents and children, grandparents and teenagers, and great-grandparents and great-grandchildren. It is my desire that as you look at the past, you also consider the future. I will have succeeded in all this if, after reading this book, you feel the same way I do about the great city of Sioux Falls.

I hope this book will be educational enough for you to look back and gain insight into the history of our city and what life was like for an early settler. So many things have changed in our world since the time Sioux Falls was first being settled. A pioneer who would still be alive today could say, "Times must be stressful; it seems everyone walks around with their hand on their ear talking and laughing with themselves." And if we tried to explain what a cell phone was, he would not understand. After all, he grew up before electricity—without light bulbs, televisions, telephones, iPods, or the Internet. I hope this book will be entertaining enough for people of all ages to take interest in the historical information included in it and be brought together by the stories of the past.

I have done my best to use the resources that are available to be accurate on dates and facts regarding the history of Sioux Falls. Not every past author agrees, so it has been difficult to decipher what is correct. Included in this book are some stories that few people know about Sioux Falls. It was my goal to show pictures of how things looked during earlier times. If you are looking for detailed chronological information about the history of Sioux Falls, three books are excellent: *Sioux Falls in Retrospect* by R. E. Bragstad; *History of Minnehaha County, South Dakota* by Dana R. Bailey; and *A Comprehensive History of Minnehaha County, South Dakota* written by Charles A. Smith. Another valuable Sioux Falls history book is *Sioux Falls South Dakota a Pictorial History* by Gary D. Olson and Erik L. Olson.

There are many interesting stories that accompany the photographs included in this book. One story is about a building that was built as a college and was later used as an orphanage, a seminary, and today as a veterans hospital. Another story is about Dr. Josiah Phillips, one of the founders of the city, performing one of the first surgeries in Dakota Territory on W. W. Brookings, when he amputated both of Brookings' frostbitten legs. Dr. Phillips had to use household and kitchen tools with no anesthetic. Brookings was one of the state's governors and had the town of Brookings named in his honor. Another story that is less heard is of Sioux Falls being the divorce capitol of the nation at one time—people from outside the state could live in Sioux Falls for a short residency and then quickly get divorced. Also, you might not know that beneath Sioux Falls are huge deposits of quartzite rock, which was, and still is, quarried.

In the early years, this rock was shaped into paving stones and building stones. These stones were a great source of revenue for Sioux Falls through the selling of the stones to Chicago, Omaha, Minneapolis, St. Louis, and Detroit. Many of the early Sioux Falls buildings that stand today were constructed with this beautiful pink/purple/gray quartzite rock. It is interesting to note that our first schools were named after early American poets and presidents: Longfellow, Hawthorne, Whittier, Lowell, Irving, McKinley, Washington, and Lincoln. Railroads helped in the growth of Sioux Falls when they came and supplied easy rail access from many other states. Today there are two main interstates that cross in Sioux Falls, continuing this easy access from other parts of the country. One last story is that of the USS *South Dakota* Battleship Memorial. This battleship was honored as the most highly decorated battleship of World War II and is now located in Sioux Falls.

Sioux Falls has a fascinating history as one of the first established cities in Dakota Territory (North and South Dakota). The name and city developed around the impressive rock formation and waterfalls of the Sioux River. Looking back, one could feel regret for tearing down the old buildings that helped establish our city. However, they are gone now and cannot be replaced. But the locations where these buildings once stood have been well utilized with new development to improve our ever-expanding city. I hope you enjoy this glimpse of the history and heritage of the great city of Sioux Falls.

One

FROM A VILLAGE
TO A CITY

In 1856, the Western Town-site Company of Dubuque, Iowa, acquired land surrounding the falls of the Big Sioux River. Settlers were led by Sioux Falls pioneer Dr. George M. Staples, who heard of Sioux Falls from explorer Joseph Nicolas Nicollet. This company established the first town site organized in the Dakotas by taking up 320 acres near the falls. By the spring of 1857, the Dakota Land Company of St. Paul claimed 320 acres to the south of the land occupied by the Western Town-site Company. In July 1857, the two companies deserted the new settlements for fear of the Sioux. In June 1858, local Sioux created an uprising and tried to drive the new Sioux Falls settlers out of the area, eventually succeeding. On August 25, 1862, the Sioux, led by Inka-pa-duta, murdered Judge J. B. Amidon and his son William near what is now St. Josephs Cathedral. Settlers abandoned the village on an order from South Dakota governor Dr. William Jayne in Yankton on August 28, 1862.

Years passed before the early Sioux Falls settlers returned to claim land in the Sioux Falls area. On May 1, 1865, Company E, 6th Iowa Cavalry established a military post called Fort Dakota in Sioux Falls, after members of the legislative assembly of Dakota Territory requested protection for the settlers from attacks of the hostile Sioux. During the summer of 1865, the Iowa Calvary built a barracks and small stone house, located between Seventh and Eighth Streets and Phillips Avenue. Newly secure, settlers slowly gained courage to return and settle into the area. The barracks remained a military post until 1870 and were removed in July 1873. Fort Dakota served as a military reservation until 1870. On August 9, 1871, Dr. Josiah L. Phillips had recorded the original town site consisting of nine blocks, which are still contained in present downtown. The Sioux Falls Village was incorporated in January 1877. Sioux Falls Village received a city charter, becoming the City of Sioux Falls on March 3, 1883.

One of the most important resources of the Sioux Falls area has been the presence of quartzite or jasper. This beautiful pink rock, quarried locally, was used to build many impressive buildings that still stand, as well as paving stones used in the streets of Chicago, Omaha, Minneapolis, St. Louis, and Detroit. The Sioux River has several cascades as the water drops nearly 100 feet in half a mile. The Cascade Milling Company, Queen Bee Milling Company, and the Drake Polishing Works were some of the industries that used the falls to generate power.

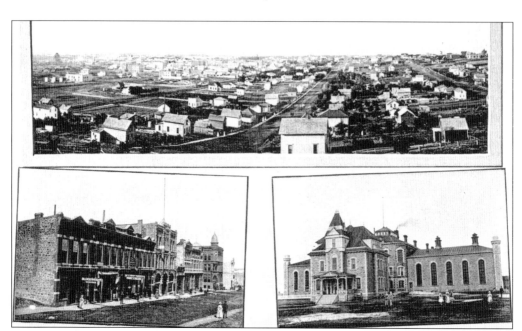

This group of photographs shows how the city looked in 1888. The top picture shows the city looking south near North Main Avenue. The bottom left picture shows Main Avenue looking north from Tenth Street. The picture on the bottom right shows the South Dakota Penitentiary.

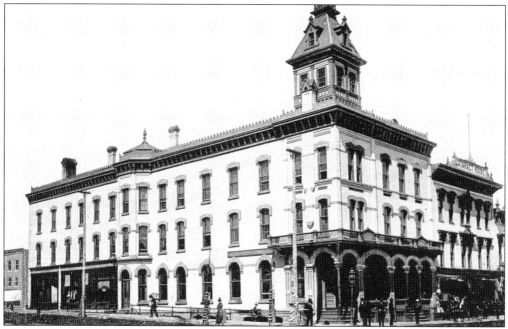

The Cataract Hotel was a central location for news and business in Sioux Falls. This was the community information center for distributing news from outside the city. This was also the meeting place for local business leaders to discuss plans for the new city. This hotel held such esteem in the community that the city began its street numbering from its intersection at Ninth Street and Phillips Avenue.

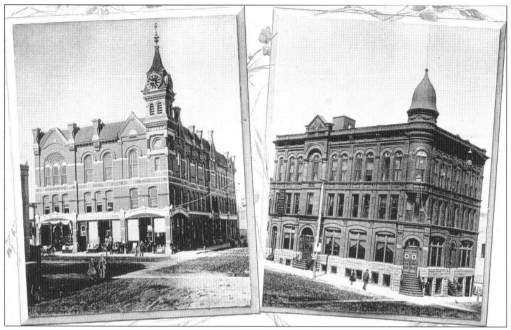

The left picture shows the Masonic temple built in 1884 on the southwest corner of Tenth Street and Phillips Avenue, the present-day Piper Jaffray building. This building was also known as the Peck Block. The picture on the right shows the Metropolitan Block built in 1886 on the northwest corner of Ninth Street and Main Avenue.

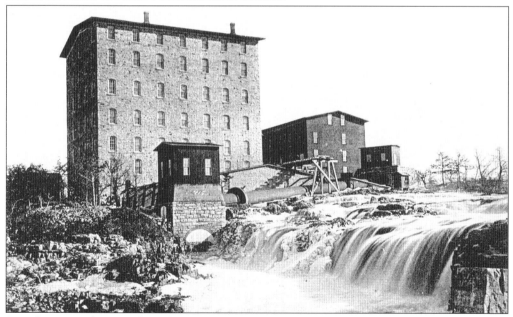

Seen here is a photograph of the Queen Bee Mill completed in 1881. The purpose of this mill was to grind wheat with the power generated by the water of the falls. The mill did not succeed and closed in 1883. The building was later used by other unsuccessful milling companies. On January 30, 1956, the building was destroyed by fire. The ruins of the mill are preserved as a part of Falls Park.

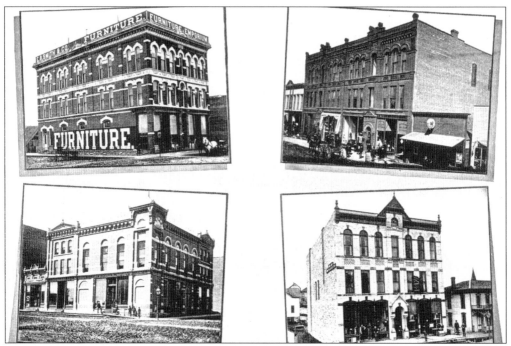

The above picture shows early buildings of 1888. The top left is the Leader Block with the E. B. Smith Company Furniture Store. The top right is the Beech Pay building also called Peck Block and Norton and Murry Block. The lower left picture is of the Sherman Block. The lower right picture shows the GAR hall also called the Briggs and Robinson building.

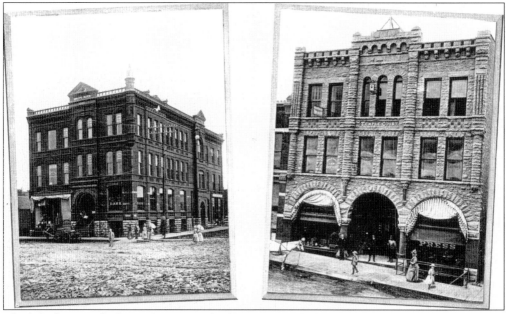

The left photograph shows the VanEps building as it looked in 1889. This building was located on the southwest corner of Eighth Street and Phillips Avenue. This was a general merchandise and office building until 1969, when it was razed. The photograph on the right shows the Temple Court in 1889.

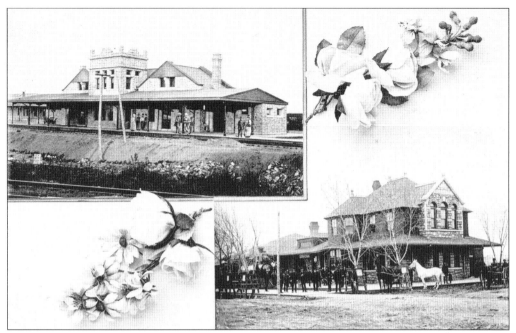

On July 30, 1878, the first train arrived in Sioux Falls. Railroads continued to expand to Sioux Falls. Many new people with money and supplies were eager to settle in the community, resulting in the Dakota Boom. The above depots are the Illinois Central (left) and the Burlington Cedar Rapids and Northern Railroad (right).

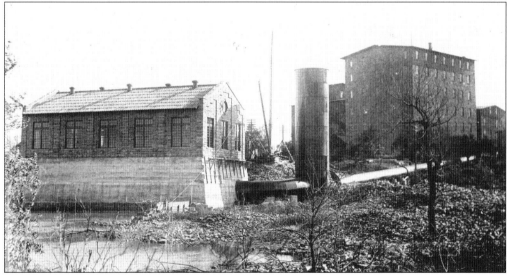

The building on the left was the Sioux Falls Light and Power Company, which provided hydroelectric power for streetlights. This building was renovated into the Falls Overlook Café in 2005. The building on the right was the Queen Bee Flour Mill. The Queen Bee Flour Mill was in business for a short time, 1881–1883. The building stood vacant for many years. A major fire destroyed the Queen Bee Flour Mill in 1956.

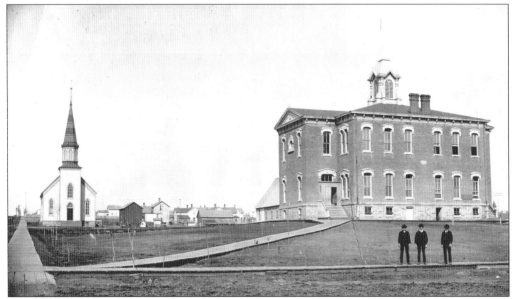

This photograph looks west from Twelfth Street and Main Avenue. The building on the left was the St. Olaf Church (eventually became First Lutheran Church). The bigger building to the right was Central School, built in 1878, around which Washington High School was later built. The building behind Central School, with its slanted roof slightly showing, was the Congregational church building also called God's Barn. (Courtesy Siouxland Heritage Museums, Sioux Falls, South Dakota.)

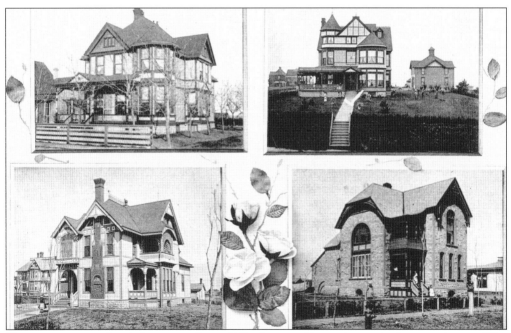

Here are pictures of early homes in Sioux Falls that would now be in the historic district. The picture on the lower right shows the home of Wilbur A. Dow that was designed by his brother, the famous Sioux Falls architect Wallace L. Dow.

Two

SCHOOLS

In 1871, Sioux Falls provided its first means of public education. For a few years and before any city schools were built, school was taught in makeshift classrooms. One of the earliest classrooms was in a sod shanty on north Main Avenue, near where the brewery (1895) was once located. Mr. Leonard was the teacher for this early school in the sod house. The barracks of former Fort Dakota were another place where school was taught in early Sioux Falls. Mrs. E. H. Darrow taught in the barracks around 1872.

On April 29, 1873, the first school meeting took place at the barracks. The first elected officers included: R. F. Pettigrew (South Dakota's first senator), Armetus Gale (early settler and brother of Helen McKennan), and D. S. Goodyear. On September 15, 1873, the first official schoolteacher was hired, and the first public school was opened. Clara Ledyard taught out of Libbey's Hall on east side of Main Avenue between Seventh and Eighth Streets. The Libby building was divided into two sections—the front half was a meat butcher shop, and the rear half was used as a school and sometimes as a church.

On December 5, 1873, the first schoolhouse was built by Edwin Sharp and completed on the site of the current Washington Pavilion. Toward the end of 1875, more classroom space was needed. The Methodist church, located at Main Avenue and Eleventh Street, provided the needed space. In November 1879, Phillips Hall was also leased for additional classroom space.

Early on, elementary school was the focus of education. In 1879, high school was offered on a volunteer basis. By the early 1890s, more classrooms were needed for students in the higher grades. In 1895, the Sioux Falls school board began leasing the St. Rose's Academy, located at the site of Irving school at Eleventh Street and Spring Avenue. This was the first official high school building. This school was Irving High School until 1901, when the school was renamed McKinley High School to honor recently assassinated president William McKinley.

With a growing need for high school space, a new high school was to be built next to Irving (Central) School. In 1908, this new school was renamed from Sioux Falls High School to Washington High School in recognition of George Washington.

As Sioux Falls continued to grow, schools were built to meet the educational needs of the city. At the beginning of the 2006–2007 school year, there were 22 elementary schools, 5 middle schools, 3 high schools, and 1 alternative school (combined middle and high school).

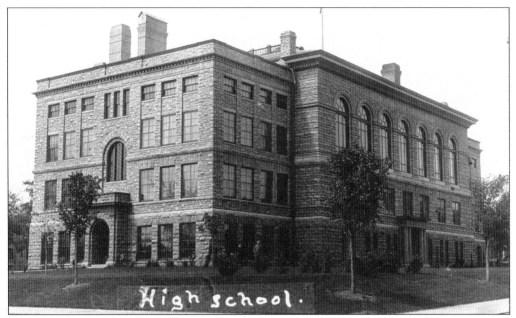

In 1906, a new high school was built. In 1908, Sioux Falls High School was renamed Washington High School in recognition of the first president of the United States, George Washington (1732–1799). This building functioned as a high school until 1991. The new Washington High School was built at Sixth Street and Sycamore Avenue. The old school building was totally remodeled and made into the Washington Pavilion.

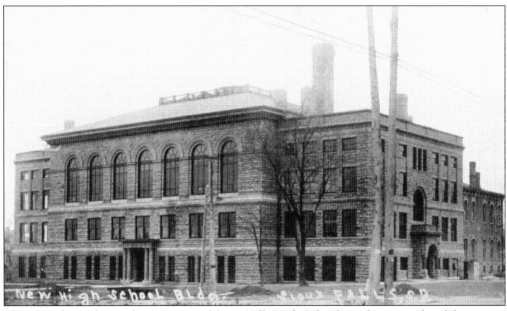

This view shows the northwest corner of Sioux Falls High School. To the very right of the picture one can see the small original school building of Central School, which was also called Irving High School. The Washington High School was built around the Central School building. In 1935, the Central School building was razed in order to build the west wing of Washington High School.

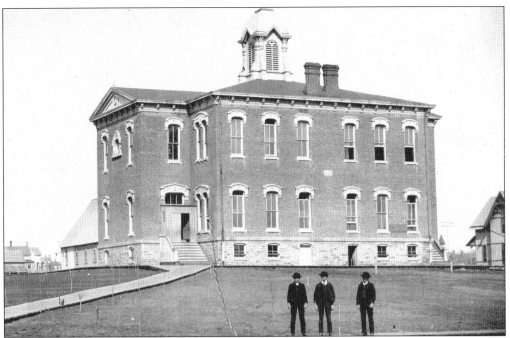

Central School building was completed in the spring of 1879. In 1885, the school board changed the name to Irving High School to honor American author Washington Irving. Many of the early schools were named after early American authors and United States presidents. This school, if still here today, would be located in the center of the Washington Pavilion. (Courtesy Siouxland Heritage Museums, Sioux Falls.)

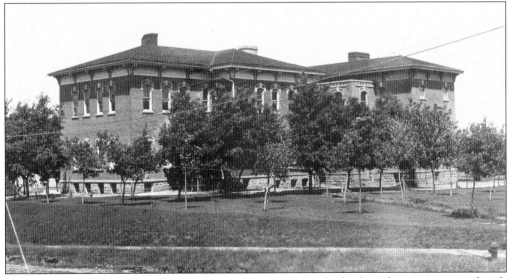

Whittier School was identical to the first Hawthorne School—built at the same time and with the same design. Both were completed in 1882. School began in January 1883. By 1908, there were two additions built onto the school. The three sections of the school were named John, Greenleaf, and Whittier for the poet with the same name. In the mid-1920s, the current school was built and the Greenleaf section was moved and became Lewis Heights School until 1932. The school became a junior high school in 1956.

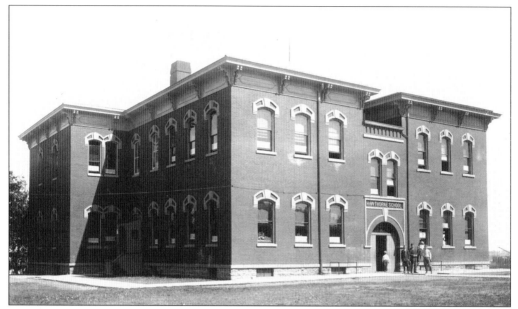

Hawthorne, Sioux Falls's North School, has undergone many changes from when it was built in 1882 until now in its present location. In 1885, the Sioux Falls School District renamed the Sioux Falls North School to Hawthorne in honor of the American novelist and short-story writer Nathaniel Hawthorne. The original school structure was identical to Whittier school, Sioux Falls's East School.

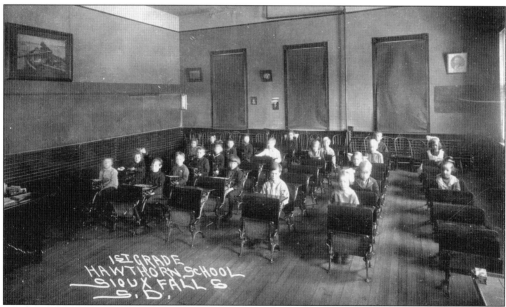

This view shows a classroom of Hawthorne School. Hawthorne hillside was the site of the Minnehaha Springs of early Sioux Falls. The Minnehaha Springs was reputed to have magical powers. The Sioux Native Americans used the springwater for medicinal purposes. The springs were later taken over by the Heynsohn brothers, and the water was bottled and sold. The southeast entrance of the current school has incorporated some of the Heynsohn Brothers building.

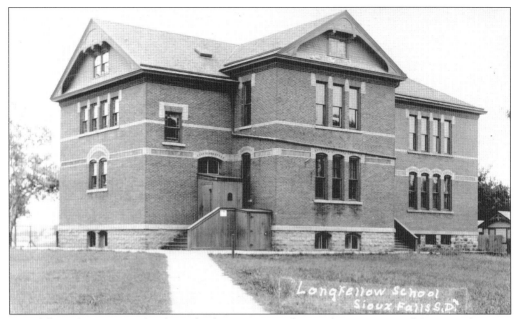

Longfellow elementary school was built in 1884 on the southwest corner of Fourteenth Street and Seventh Avenue, where the old Beadle School is now located. The school was named after the famous American poet Henry Wadsworth Longfellow. This was the fourth school to be built in Sioux Falls. In 1914, the current Longfellow School was built at Fourth Avenue and Twentieth Street. (Courtesy Mike Wiese.)

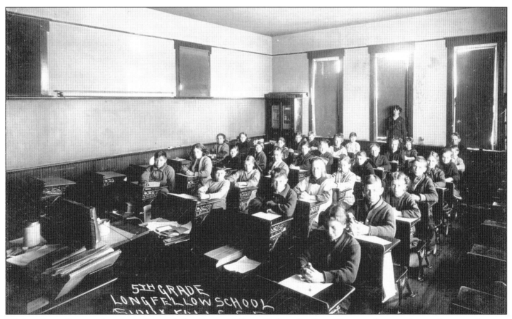

This view shows the interior of the Longfellow School when it was located on the southwest corner of Fourteenth Street and Seventh Avenue. After moving to the new Longfellow School in 1914, the original school was used as a warehouse until 1921, when it was razed and Beadle School was built.

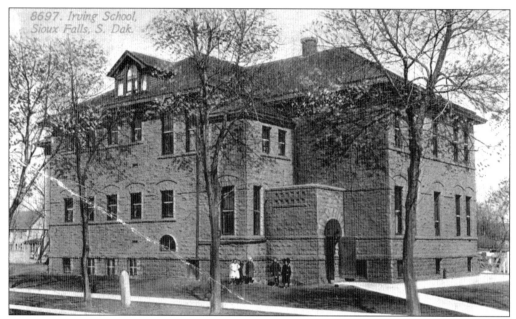

This building was constructed in 1883 at Eleventh Street and Spring Avenue and was originally used as St. Rose Academy. In 1895, the school became Irving High School. In 1901, the school was renamed McKinley High School, in honor of Pres. William McKinley. In 1907, the high school students moved to the new Washington High School and McKinley High School turned into Irving Elementary School. The original building was razed in 1935, and a new Irving Elementary building was constructed in the same location.

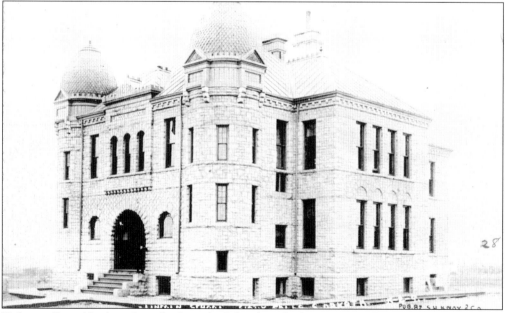

To honor Pres. Abraham Lincoln, Lincoln School was built in 1888 on the block between Eighth and Ninth Streets and Grange and Euclid Avenues. This building was replaced by a new school with the same name in 1916. In 1939, a new addition was built, and the building stood until 2006 when Lincoln School was razed and the grounds were developed into a city recreation area.

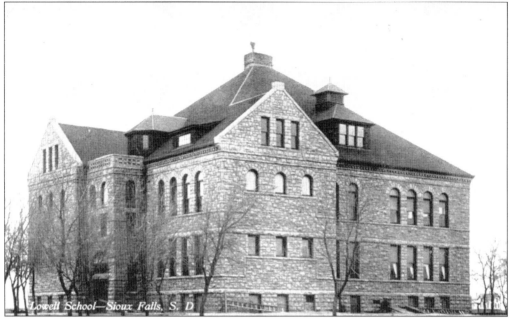

In 1891, the seventh Sioux Falls school was built and named after American poet James Russell Lowell. Located at Eighteenth Street and Prairie Avenue, Lowell Elementary School had a history of three fires. Between 1934 and 1936, two additions were made to the building. In 1967, the east addition was added to the school, and the original Lowell section was razed. Today Lowell Elementary School is still being used for education.

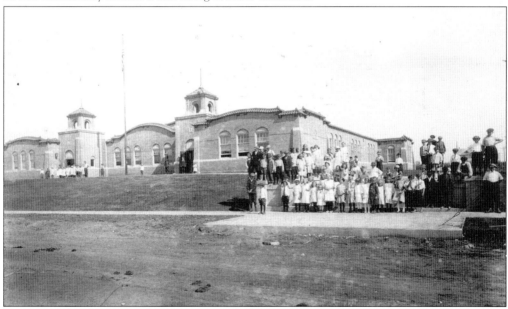

In 1915, Bancroft School was built on the corner of Eighth Street and Blauvelt Avenue. Most likely Bancroft School was named after George Bancroft, an American historian. The 1997–1998 school year was the last for Bancroft and Franklin Schools—in the fall of 1998, students from both schools attended Terry Redlin Elementary, which was completed in 1998 on the Bancroft School grounds.

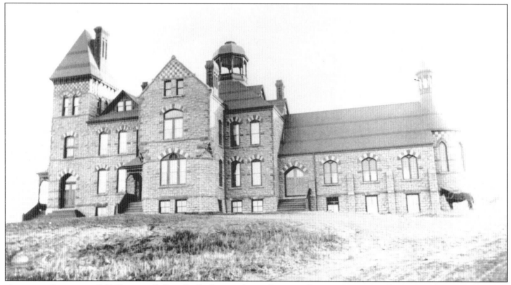

A view showing All Saints School, dedicated on September 17, 1885. The school grounds and buildings were built between Phillips and Dakota Avenues and between Seventeenth and Eighteenth Streets. Bishop William Hobart Hare was integral in establishing and getting monies for the construction of this all-girls preparatory school. The buildings were remodeled in 1996, and the retirement community of Waterford at All Saints was established. (Courtesy Waterford at All Saints.)

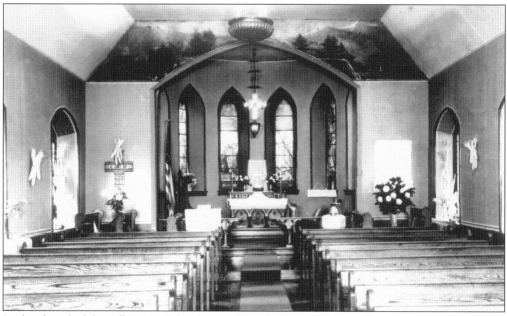

In the chapel of the All Saints School, now Waterford at All Saints, there are some of the rarest and most beautiful Tiffany stained-glass windows found in the city. In addition to typical classes for the grade and high school courses, religious courses were also taught under the direction of the Episcopal Church.

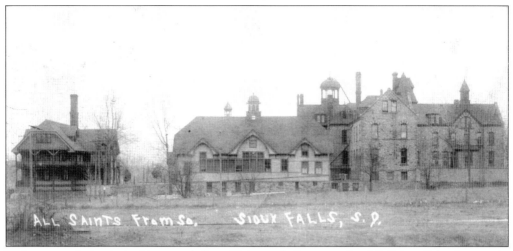

This postcard view is looking north from Eighteenth Street at the All Saints School grounds. The main school building is to the right. The building in the center of the picture is the Dexter Memorial House, which was built in 1904 and moved to 2725 South Carolyn Avenue in 1992, where it is functioning as the Timothy's House of Hope. (Courtesy Mike Wiese.)

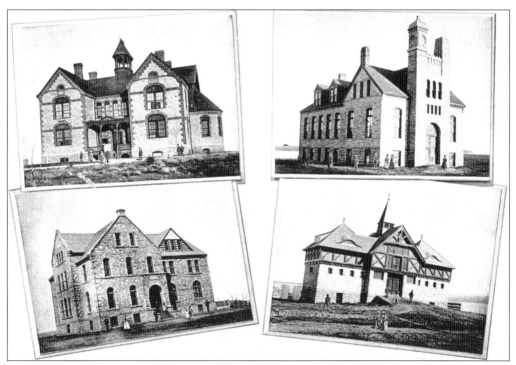

In 1880, Rev. Thomas Berry began an institution to educate deaf people. Reverend Berry began his teachings in his home, then moved into the Thomas Lodging House, and finally onto the grounds of the current South Dakota School for the Deaf. In 1817, after traveling to Europe to learn methods of communication with deaf people, Thomas Hopkins Gallaudet founded the nation's first school for deaf people in Hartford, Connecticut.

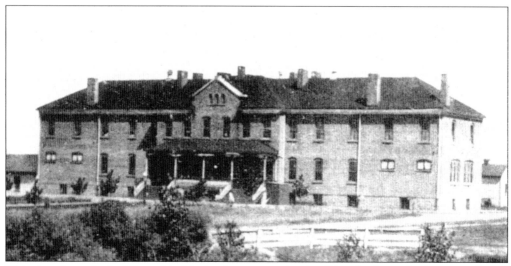

This view shows the building of the Native American school in Chamberlain, which was purchased by Bishop Thomas O'Gorman and in 1909 converted into Columbus College, a preparatory school, high school, and college for Catholic boys. The school later moved to Sioux Falls, into the northwest part of the Veterans' Administration Medical Hospital. The Chamberlain school building was sold to the St. Joseph's Indian School, which continues today.

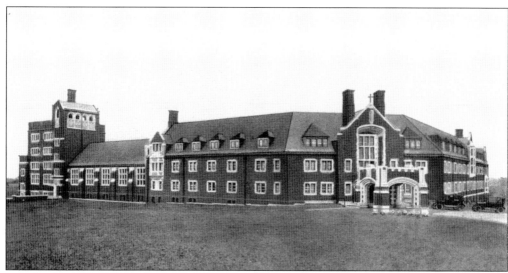

Classes began at Columbus College in Sioux Falls on September 16, 1921. In 1929, the school closed and was later used as Columbus Junior College and Normal School for girls, as an orphanage, and then as St. Bernard's Seminary. After 1943, the War Department of the government took over the building and eventually added onto the southeast part of the building; this became the Veterans' Administration Medical Hospital and continues as such today.

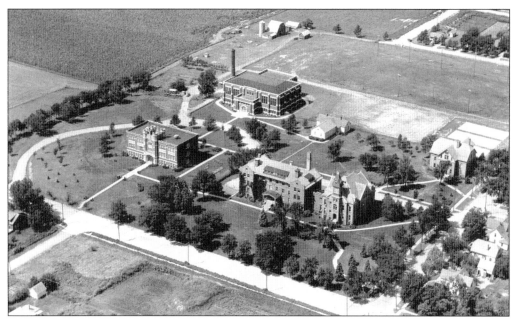

This view shows the Augustana College campus in the 1940s. Notice the farm at the top middle part of the picture located west of where the humanities building is now located. There is a field in the upper right corner, which was used as a football field. The main buildings include the administration building, completed in 1920 (far left); gymnasium, completed in 1937 (top center); Old Main, completed in 1889 (middle right); and ladies hall, completed in 1895 (upper right).

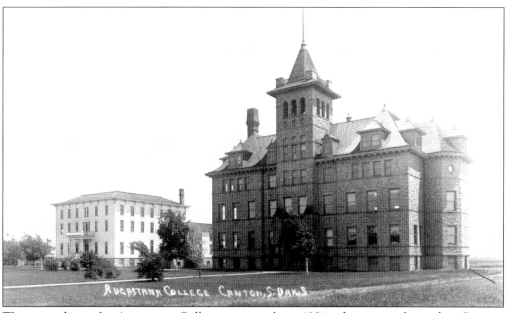

This view shows the Augustana College campus about 1904, when it was located in Canton, South Dakota, (1884–1918). The building to the left was the Naylor House Hotel, moved from downtown Canton in 1902 and renamed Sorum Hall. The building to the right was dedicated in 1903. This campus later became Augustana Academy.

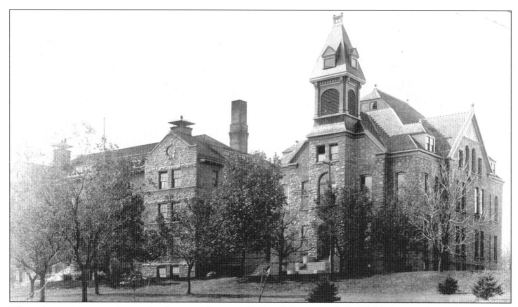

The above picture shows Lutheran Normal School, later called Old Main when the campus became Augustana College. Augustana College was first established in 1860 in Chicago and later moved to Paxton, Illinois; Marshall, Wisconsin; Beloit, Iowa; Canton, South Dakota; and finally, to Sioux Falls, when it merged with the Lutheran Normal School in 1918.

This is a beautiful historic building on the campus of Augustana College. The administration building was completed in 1920. This photograph shows the east side of the building facing Summit Avenue.

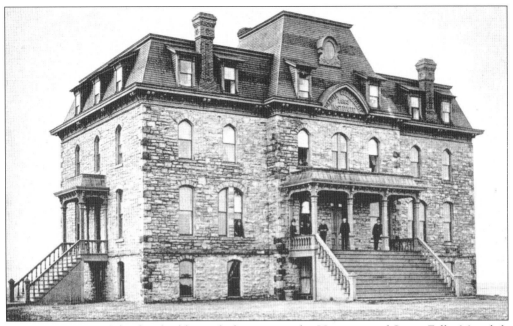

This is a picture of the first building of what is now the University of Sioux Falls. Meredith Hall was named in honor of Rev. E. B. Meredith, the university's first president. The school began in 1883 as Dakota Collegiate Institute. In 1885, the school reorganized into Sioux Falls University. In 1898, the name changed to Sioux Falls College. In 1994, the name changed to the University of Sioux Falls.

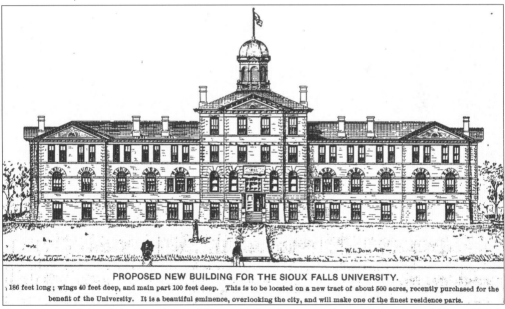

PROPOSED NEW BUILDING FOR THE SIOUX FALLS UNIVERSITY.

186 feet long; wings 40 feet deep, and main part 100 feet deep. This is to be located on a new tract of about 500 acres, recently purchased for the benefit of the University. It is a beautiful eminence, overlooking the city, and will make one of the finest residence parts.

At one time, Meredith, president of Sioux Falls University (now University of Sioux Falls), had proposed an additional university building in West Sioux Falls. The location was one mile southwest of Louise and Maple Streets. The architect was Wallace L. Dow. The building was never built due to financial problems related to the national depression of 1893. (Courtesy University of Sioux Falls Archives, Norman B. Mears Library.)

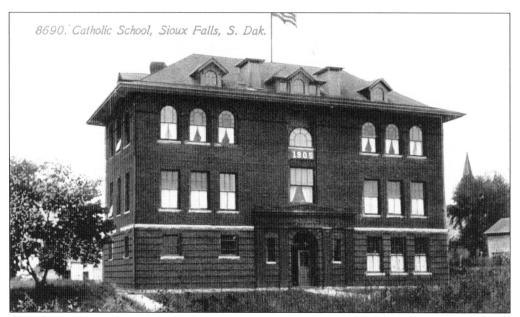

The above picture shows the Catholic School, which began in 1905 north of St. Michael's Church. The Cathedral School building of today was built in 1926. The St. Rose Academy was the first Catholic school to be built in Sioux Falls in 1890 and was located at Eleventh Street and Spring Avenue. It continued until 1895, when the school closed and was converted to Irving High School.

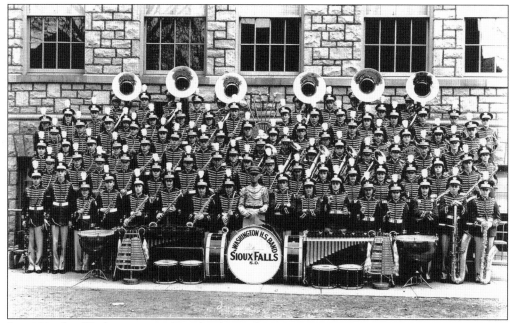

In 1929, the Washington High School Band was organized under Arthur R. Thompson, conductor. This was the first of excellence in concert and marching band music in Sioux Falls. With their distinct look in actual military outfits and their incredible sound, the band awed concertgoers, entertained parade watchers, motivated sports fans, and excelled at contests. Today high school bands share the same competitive nature as their fellow sports teams.

Three

CHURCHES

In early Sioux Falls, the church functioned not only as a place to worship, but also as a place to meet. New homesteaders in the area knew they could find like-minded folk by finding a church organization that was familiar to what they had left behind. In today's church, new members usually come from a similar denomination or religion of their previous church. Long ago, people would decide on a new church due to the church's heritage, Norwegian, Swedish, German, and the like.

Most churches were first formed in people's homes or in basements of other businesses. As a church body would grow, they would eventually construct a building or would merge with a similar church. In 1872, the first church structure was built on the northwest corner of Ninth Street and Main Avenue. This was the Episcopal church building. Within a few years, many more churches were built for different Christian denominations. Many of Sioux Falls's most beautiful buildings were churches. Some of the church buildings that still stand today include St. Joseph's Cathedral, Calvary Episcopal Cathedral, First Congregational Church, First United Methodist, First Lutheran Church, Eastside Presbyterian, Faith Temple Church, Apostolic House of Deliverance, Augustana Lutheran Church, and Eastside Lutheran Church.

It is the author's opinion that looking back at history helps one to look forward to the future. One can think of the early Sioux Falls pioneers who have died and consider what they believed when they walked the streets of Sioux Falls to be important in determining where they would spend eternity. Nearly all of the early pioneers were members of a Christian church with nearly all of them attending weekly. Today's national averages show below 50 percent of people attend church weekly in all denominations and religions.

The Calvary Church (Episcopal) was the first church building constructed in Minnehaha County in 1872. It was located on the northwest corner of Ninth Street and Main Avenue. (Courtesy D. R. Bailey.)

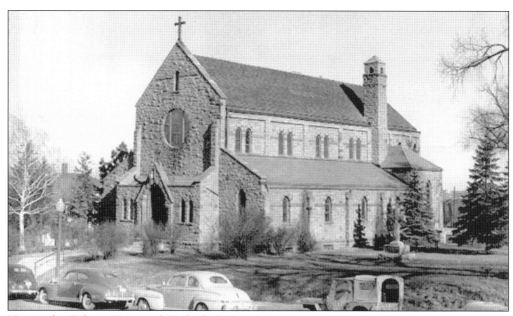

Here is the Calvary Episcopal Cathedral Church as it was in 1946. Building on this church was complete in 1889. Today's Calvary Cathedral was formed by the congregation of the Calvary Parish from the Calvary Church (Episcopal) and the building of the Church of St. Augusta. This view is looking northeast before the additions were completed to the south. (Courtesy Calvary Episcopal Cathedral.)

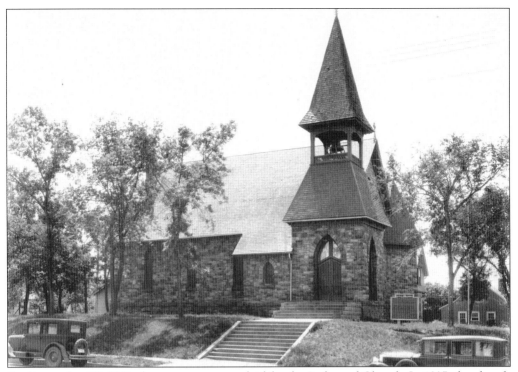

On September 29, 1883, the cornerstone was laid for the Reformed Church. In 1897, the church was renamed Livingston Memorial Reformed Church to honor founding pastor Rev. E. P. Livingston. The church had a rare visit on Palm Sunday, 1903—Pres. Theodore Roosevelt was in Sioux Falls and attended church that day. Since 1913, the church has been called Eastside Presbyterian Church. (Courtesy Eastside Presbyterian Church.)

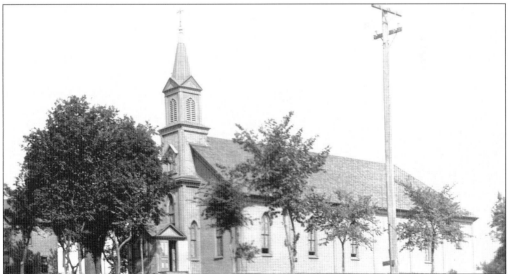

In 1877, Catholic church services began in Sioux Falls. A frame church was built in 1879 at the location of the current St. Joseph's Cathedral. Two years later, the church was destroyed by fire. The above picture shows the St. Michael's Pro-Cathedral, which was built in 1883 to replace the earlier church.

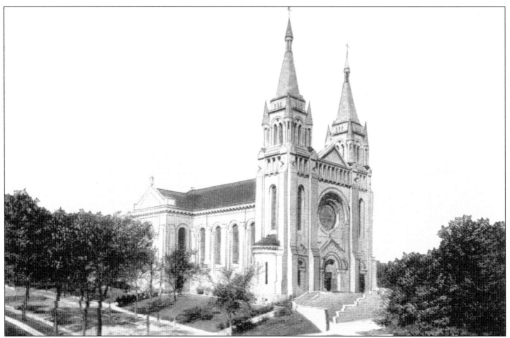

The St. Michael's Pro-Cathedral was moved to the north end of the block using a horse and wheel to make room for the construction of St. Joseph's Cathedral. Bishop Thomas O'Gorman came to Sioux Falls in 1896 and had a dream of a Catholic cathedral. The cornerstone was laid in 1916, and the cathedral was dedicated in 1918. The first mass was done by Bishop O'Gorman.

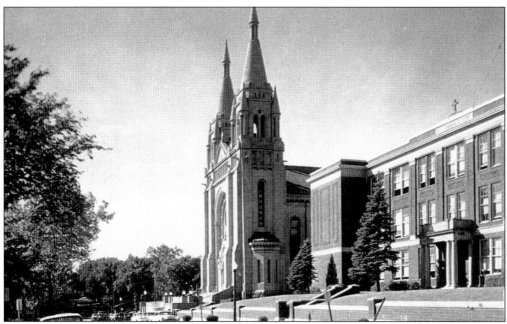

This picture shows St. Joseph's Cathedral on the left and Cathedral School on the right. The original Cathedral School was razed, and this school was built in 1927 and continues today as St. Joseph Cathedral School, providing education for preschool through sixth grade.

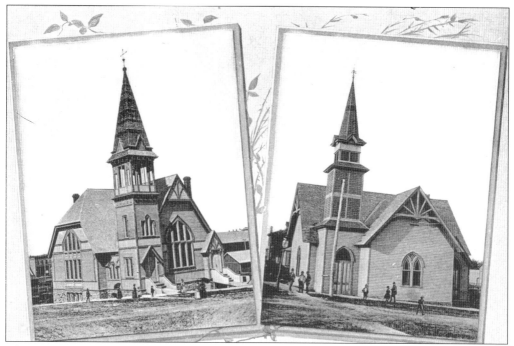

These were the first churches for the Baptist (left) and Presbyterian (right) congregations in Sioux Falls. The Baptist church was built in 1882 on the northeast corner of Eighth Street and Dakota Avenue where the downtown library is located. The Presbyterian church was built in 1885 on the northeast corner of Ninth Street and Minnesota Avenue.

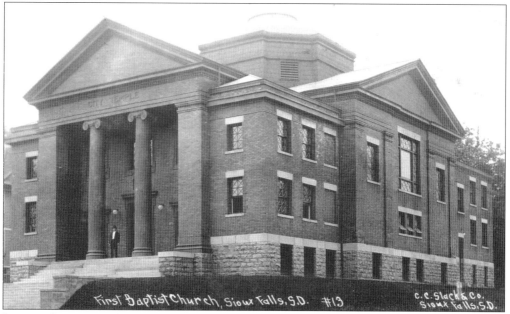

In 1910, this Baptist church, known as the City Temple, was completed. The church was located on Eighth Street and Spring Avenue and continued in this location until 1951, when the church moved to its current location. After it moved, Central Baptist used the building for many years. Currently the building is occupied by the Faith Family Church congregation.

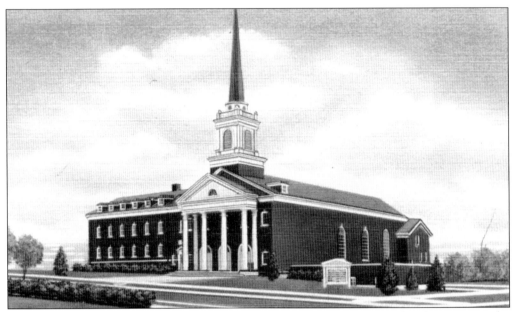

This was the third and current location of the First Baptist Church, completed in 1951 on the southwest corner of Twenty-Second Street and Covell Avenue. Directly north of Twenty-Second Street is the Sioux Valley Hospital Campus.

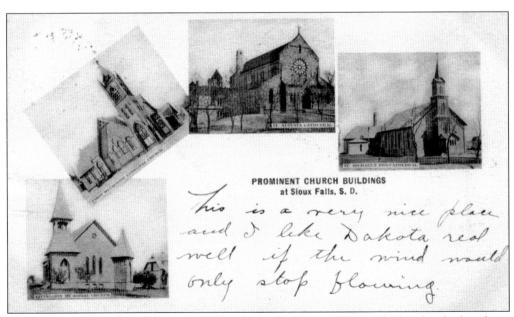

The prominent churches of the early 1900s included Livingston Memorial Church, which today is the Eastside Presbyterian Church; First Methodist Episcopal Church, whose congregation is now First United Methodist Church; St. Augusta Cathedral, which is now Calvary Episcopal Cathedral Church; and the St. Michaels Pro-Cathedral, which today is the St. Joseph's Cathedral.

34

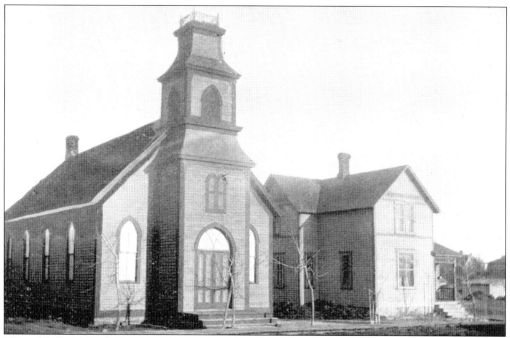

This old photograph shows the first building of the First Methodist Episcopal Church (left) and the parsonage (right) completed in 1881 on the southeast corner of Eleventh Street and Main Avenue, east of the Washington Pavilion. In 1872, the church members began meeting in the home of the Rev. G. W. Curl, which was located between Eleventh and Twelfth Streets on the west side of First Avenue.

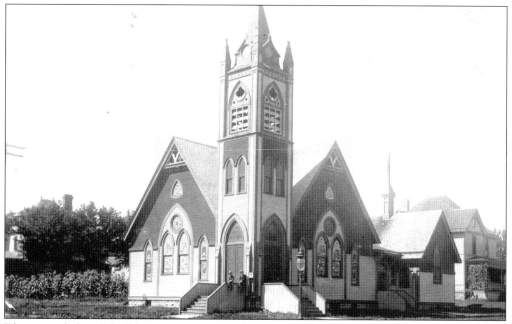

The second church building was constructed on the southwest corner of Eleventh Street and Minnesota Avenue. In 1920, the Sioux Falls Medical and Surgical Clinic began in the same location. The Firestone tire building is now located on the same corner.

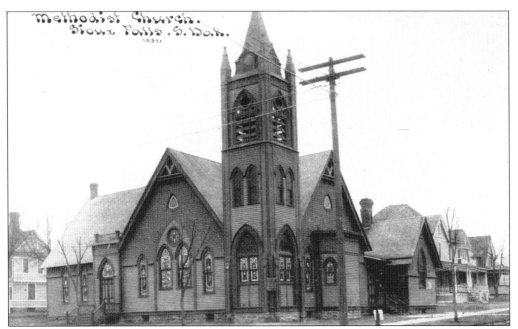

A large addition was built on the south part of the Methodist church building in 1902. To the right was the church parsonage. The church continued at this location until 1913, when it moved to its current location on the southwest corner of Twelfth Street and Spring Avenue (seen in the picture below).

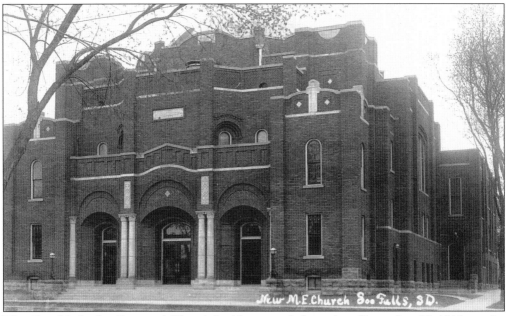

This First Methodist Episcopal Church building was dedicated on December 28, 1913, on the southwest corner of Twelfth Street and Spring Avenue. In 1939, the Episcopal affiliation was dropped from the church, and it became First Methodist Church. In 1969, the church united with the Evangelical United Brethren Churches and became First United Methodist Church. The church continues in this location today.

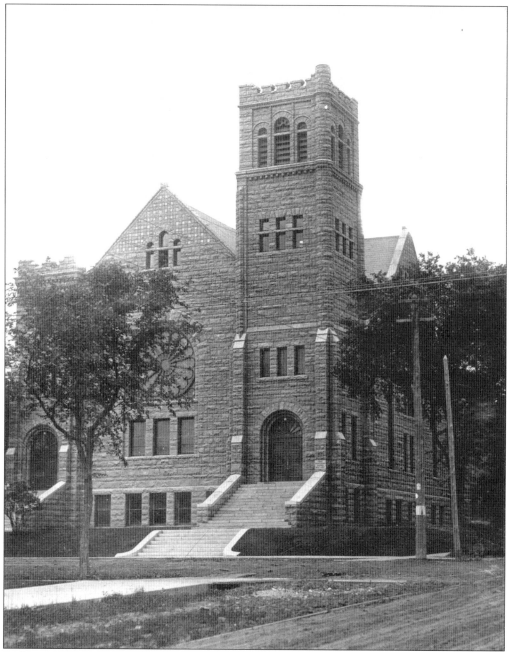

Today's First Congregational Church building was constructed in 1909 on the southwest corner of Dakota Avenue and Eleventh Street to the west of the Washington Pavilion and north of the First Lutheran Church. This church building replaced the original Congregational church building, which was also referred to as God's Barn, and was located in the same place. The church was home to many early pioneers including Armetus Gale and his sister Helen McKennan, Dr. and Mrs. Josiah Phillips (of Phillips Avenue namesake), and lumberman John W. Tuthill. Even the national philanthropist Andrew Carnegie played a part in building the beautiful church by donating a large pipe organ. This was the last church to be built with local quartzite.

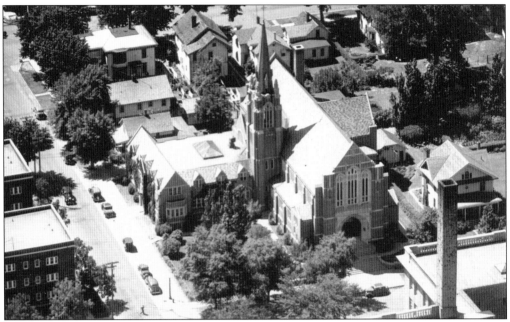

St. Olaf Church and the Grace Evangelical Lutheran Church combined to form the First Lutheran Church in 1920. After the two congregations combined, the St. Olaf Church building was used for English-speaking church services and the Grace Evangelical Lutheran Church building was used as a chapel for Norwegian services. On November 30, 1930, the First Lutheran Church was dedicated on the same location of the old St. Olaf Church.

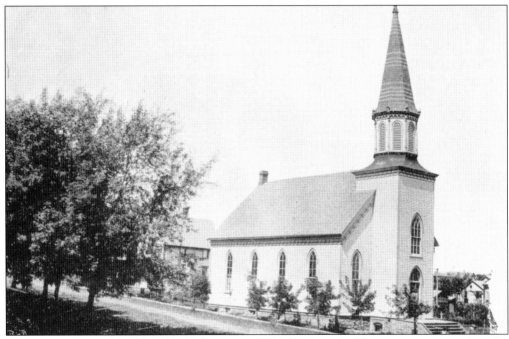

The congregation of St. Olaf Church began in 1877. The above building was constructed on the northwest corner of Twelfth Street and Dakota Avenue in 1882. The First Lutheran Church is located where St. Olaf Church once stood.

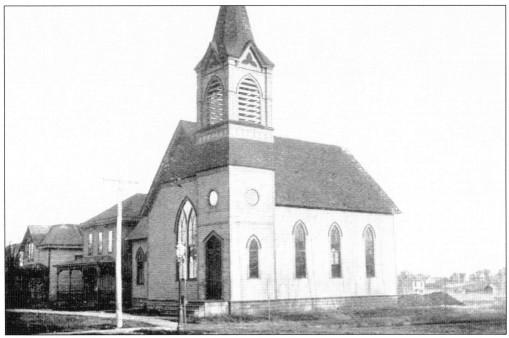

In 1894, this building was constructed for the Trinity Lutheran congregation on the southeast corner of Fourteenth Street and Duluth Avenue. The Trinity Lutheran congregation changed to Grace Lutheran congregation in 1918. In 1926, the Mount Zion Jewish Temple took over the Grace Lutheran congregation building and continues there today.

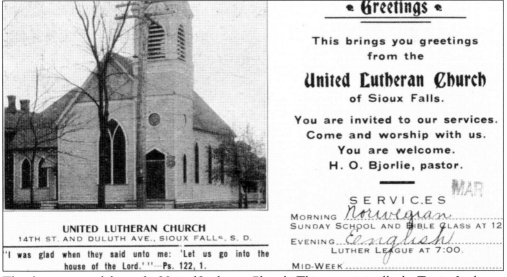

UNITED LUTHERAN CHURCH
14TH ST. AND DULUTH AVE., SIOUX FALLS, S. D.
"I was glad when they said unto me: 'Let us go into the house of the Lord.'"—Ps. 122, 1.

* Greetings *

This brings you greetings from the

United Lutheran Church

of Sioux Falls.

You are invited to our services.
Come and worship with us.
You are welcome.
H. O. Bjorlie, pastor.

SERVICES

MORNING *Norwegian*
SUNDAY SCHOOL AND BIBLE CLASS AT 12
EVENING *English*
LUTHER LEAGUE AT 7:00.
MID-WEEK

The above postcard shows the United Lutheran Church. This was originally the Trinity Lutheran Church building, later the Grace Lutheran Church, and today the Mount Zion Jewish Temple. Notice on the card that both Norwegian and English worship services are offered.

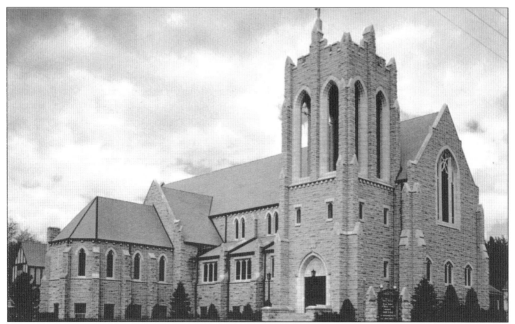

In 1911, a chapel was built at 222 North Cliff Avenue for members of the St. Olaf Church who lived in East Sioux Falls. The chapel was built into a church in 1923. The above photograph shows Eastside Lutheran Church on the corner of Tenth Street and Sherman Avenue, which began construction in 1949. The steeple was struck by lightning on April 22, 2001, between worship services, and the building was repaired to its original appearance.

This shows the All Souls Unitarian Church, completed in 1889, on the southeast corner of Twelfth Street and Dakota Avenue, south of Washington High School. This building then served as the city library until 1903, when the Carnegie Library was completed. From 1906 to 1951, this building served as the Swedish Baptist Church (later called Central Baptist Church). This building was razed in 1971.

Four

HOSPITALS

Some people often take their safety and health for granted. They assume help is just a shout away. Medicine is incredible, but this has not always been true. In 1888, in the earliest attempt to establish a hospital in Sioux Falls, Rev. Frederick Gardiner tried to build one on the east side of the river. He lasted a few months, and up until the 1890s, there was nowhere to go. Care was provided by early settlers who also happened to be doctors. There were no trained nurses, and surgical equipment was scarce. In one of the earliest recorded procedures, Dr. Josiah L. Phillips (namesake of Phillips Avenue) amputated the legs of Wilmot W. Brookings (namesake of the town of Brookings and a state governor) below the knee, without anesthesia or instruments; instead, household items were used. In the hospitals of Sioux Falls today, the surgery would be less painful, sterile, and Brookings's legs might have been saved. In 1893, a group of people from Sioux Falls went to the Chicago World's Fair and came back with a new vision.

On June 14, 1894, a group of pastors and doctors met to discuss plans for a city hospital. In attendance were Rev. Nils Boe, Dr. H. Hovde, and Dr. A. Zetlitz. The new hospital was named Sioux Falls Lutheran Hospital, as it was financed by Lutheran members of the hospital association. The first hospital building was the Seney residence at 608 North Menlo Avenue. In 1896, the hospital moved to the Cameron House at Tenth Street and Dakota Avenue. In 1900, the first building designated for hospital use was constructed in Sioux Falls, on the northeast corner of Nineteenth Street and Minnesota Avenue, where Gustaf's Greenery now stands. Later the building was moved to the southeast end of the Sioux Valley Hospital campus and used as a nurse's residence.

In the early 1900s, other hospitals in Sioux Falls included Moe Hospital, on the northwest corner of Fourteenth Street and Main Avenue (the building now houses the offices of Davenport, Evans, Hurwitz, and Smith, LLP); Dunham Hospital (now an apartment building), built in 1896 on the southwest corner of First Avenue and Fourteenth Street under the direction of Whitefield Otis Dunham, MD; and Sioux Falls Sanitarium, an emergency hospital located at 315 North Prairie Avenue in 1903 and claiming the only ambulance in Sioux Falls, which was horse-driven. Other institutions included the children's home, House of Mercy, Keeley Institute, Neal Institute, and the Sioux Falls Medical and Surgical Clinic.

Today health care in Sioux Falls is provided mainly by two organizations: Avera Health and Sioux Valley Health System. The associated hospitals provide some of the finest medical health care available.

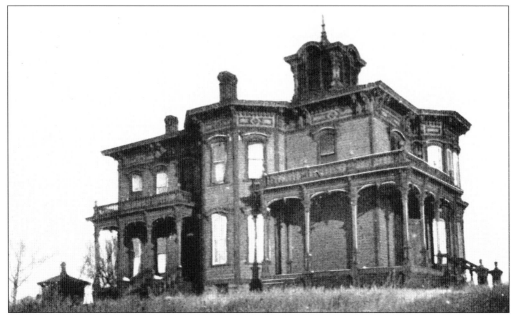

This photograph shows the Cameron House, which was the second site of the city hospital beginning in 1896. This building was located at Tenth Street and Dakota Avenue, south of where the current Quest building stands. Previously the city hospital was located in the George Seney residence at 608 North Menlo Avenue. Today the Seney residence is a home.

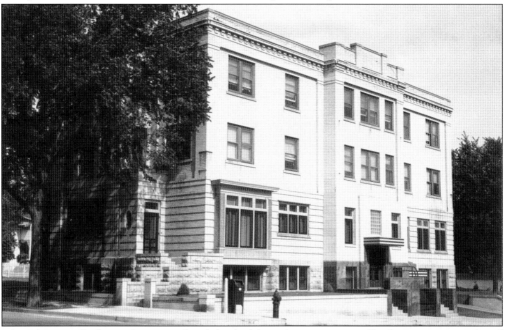

This photograph shows the east side of the building that was originally the Moe Hospital and clinic built in 1917 and operated until 1941. This building is located on the northwest side of Main Avenue and Fourteenth Street, south of Miller Funeral Home. The law firm of Davenport, Evans, Hurwitz, and Smith has occupied the building for many years. (Courtesy Davenport, Evans, Hurwitz, and Smith.)

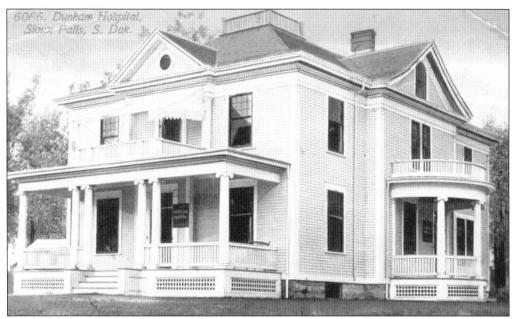

This is the Dunham Private Hospital, built in 1896 on the southwest corner of Fourteenth Street and First Avenue. Whitefield Otis Dunham, MD, began this early hospital in 1904 and continued it until 1912. Today this building is an apartment complex.

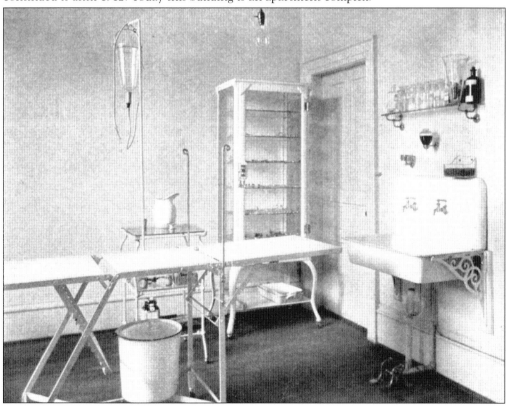

The above photograph shows the operating room of the Dunham Hospital in the late 1890s.

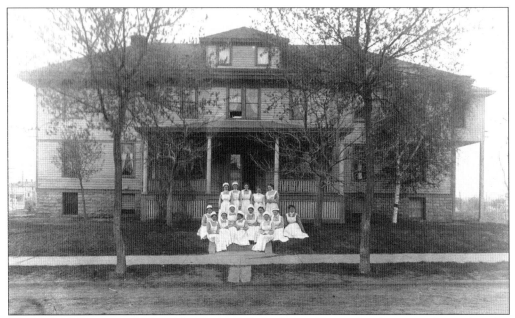

The Sioux Falls Hospital, also called Sioux Falls Lutheran Hospital early on, was located on the northeast corner of Nineteenth Street and Minnesota Avenue. This building was later moved to the south end of the Sioux Valley Hospital Campus and was used as a nurse's dormitory for many years. (Courtesy Mike Wiese.)

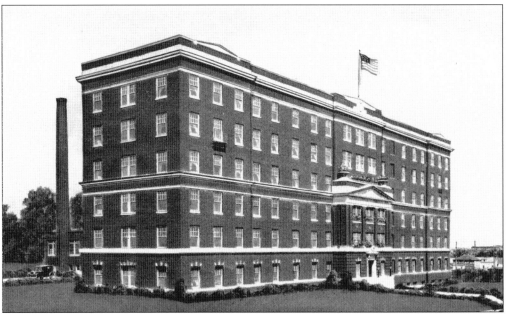

In 1925, the Sioux Falls Hospital Association and Bethany Association (owners and operators of the Moe Hospital) formed Sioux Valley Hospital Association. The above building was completed in 1930, and patients were transferred from the old hospital to this building. This hospital has been in operation 24 hours a day every day since. This building is a part of the current hospital campus west of the main entrance.

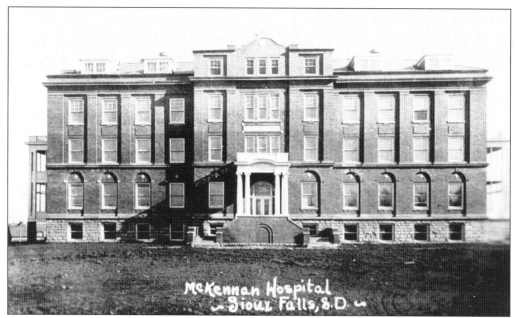

McKennan Hospital began with a large financial gift from Helen G. McKennan. On her deathbed, she gave strict orders to E. A. Sherman how she wanted her legacy to be used. Sherman, with the help of Bishop Thomas O'Gorman, was able to invite the Presentation Sisters to manage the hospital. The hospital was dedicated on December 17, 1911, and has been providing care every day since.

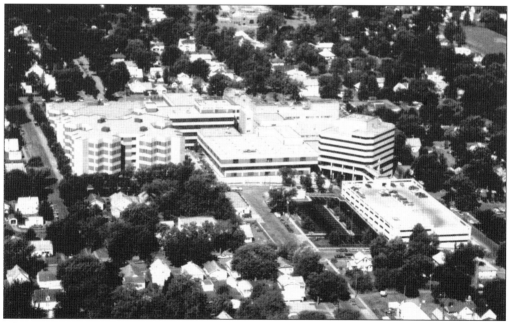

This aerial view is looking west from Cliff Avenue. Many, if not all, of the homes in the left section of the photograph have been moved, and new state-of-the-art buildings and parking lots have been built. Some of the buildings include Orthopedic Institute, Avera Cancer Institute, Doctors Plaza 1, and Doctors Plaza 2 with Center for Family Medicine.

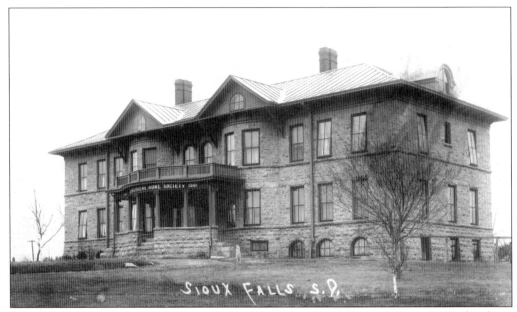

The South Dakota Children's Home Society began in 1893. From 1903 to 1969, this large building, located on the southeast corner of Tenth Street and Cliff Avenue, was used as a shelter for homeless and neglected children to find rest until a family would take them in. The building was razed in 1973 to make room for Lewis Drug Eastgate Store, which continues today.

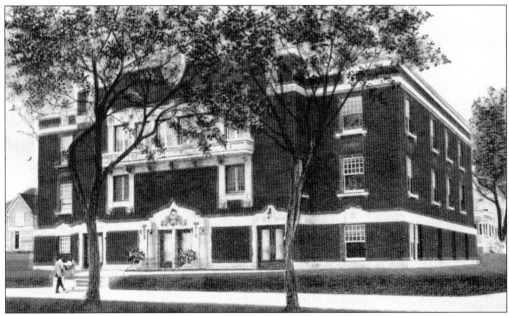

In 1920, the Sioux Falls Medical and Surgical Clinic opened in a new building located on the southwest corner of Eleventh Street and Minnesota Avenue. This building replaced the First Methodist Church. The clinic operated out of this location until 1965, when the doctors found a new location at the Donahoe Clinic. This corner is now occupied by the Firestone tire store.

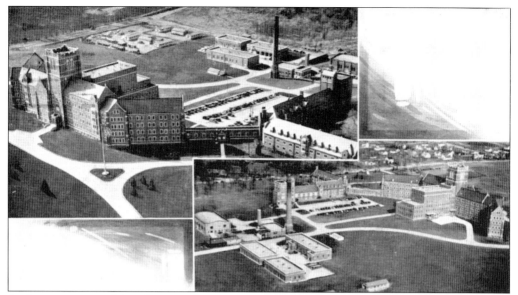

In the top picture of this photograph, one can see the veterans' hospital from the front, looking toward the southwest. The lower picture shows the hospital from behind looking northeast. The right of the top picture shows where the original Columbus College was located. The left part of the top picture shows the large addition to the hospital, which was completed in 1949.

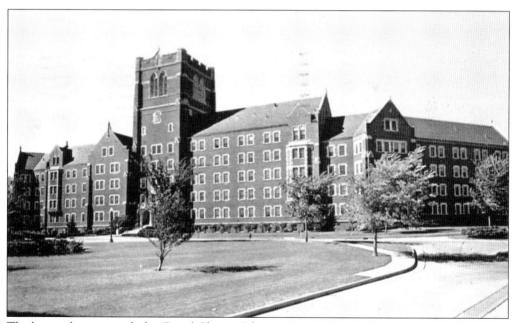

The hospital was named after Royal Cleaves Johnson (1882–1939). Johnson was a South Dakota Congressman in the United States House of Representatives from March 1914 to March 1933. He absented himself from the United States House of Representatives and enlisted in the army during World War I. He was wounded in the war, and when he returned to Congress, he became an advocate for veterans' benefits legislation.

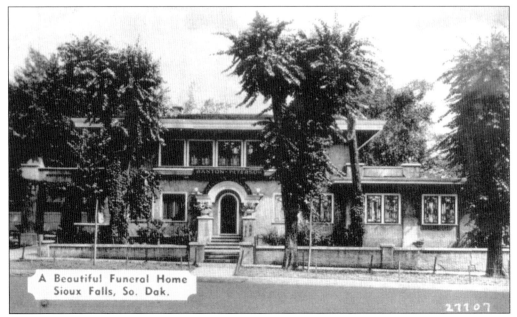

A Beautiful Funeral Home
Sioux Falls, So. Dak.

This picture shows the Banton Peterson Funeral Home, located at Eleventh Street and Minnesota Avenue, where the Howalt-McDowell Insurance building stands today. After graduating in 1948, George Boom began his funeral directing business as a partner of this funeral home in 1954. In 1956, Boom bought the entire business and the George Boom Funeral Home continued at that location until moving to its main location on East Tenth Street in 1964.

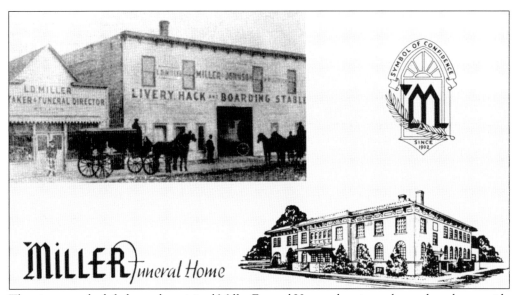

The picture to the left shows the original Miller Funeral Home when it was located on the east side of Main Avenue between Tenth and Eleventh Streets. L. D. Miller began this business in 1903. Today's Miller Funeral Home, pictured on the right, was built in 1924 at its current location, on the southwest corner of Thirteenth Street and Main Avenue. A second Miller Funeral home is located on West Forty-first Street. The picture is from the Sioux Falls Centennial Souvenir program.

Five

RAILROAD DEPOTS

The first train arrived in Sioux Falls on August 1, 1878. This was part of the Chicago, St. Paul, Minneapolis, and Omaha Railway Company. The city planners made great efforts and spent much money to build railroads. They knew that having railroads would bring many new homesteaders and would surely expand local business opportunities to grow the economy in Sioux Falls and throughout the state. Connected by the railroad system, Sioux Falls became a regional distributing center for the small towns of South Dakota and surrounding states. Sioux Falls had five rails from the east and extended its rails to the west. All travel in the area had to go through Sioux Falls. There were many opportunities that resulted in large growth and prosperity for the city in hard times. The railroads created a boom in the city for people and business from 1878 to 1889. There were luggage and passenger transfers (taxis) from the depot to the passenger's destination by Omnibus and Hack services. Later electric streetcars were used. It was not long after that when most transportation was provided by automobile. Some of the early pioneers did not like the automobile and felt that the desire for the automobile would not last. The residents disagreed, and the desire for automobiles took off. In 1903, the automobile was giving the horse and buggy so much competition for the city streets that the city council passed ordinance No. 326, which stated that it was illegal for any person to operate a motorcycle or automobile device faster than seven miles per hour on the downtown streets or alleys and four miles per hour while turning corners. Today there are only freight trains that go to and from Sioux Falls. The last passenger train left Sioux Falls in 1965. Since then, people have traveled by automobile, bus, or airplane when leaving the great city of Sioux Falls.

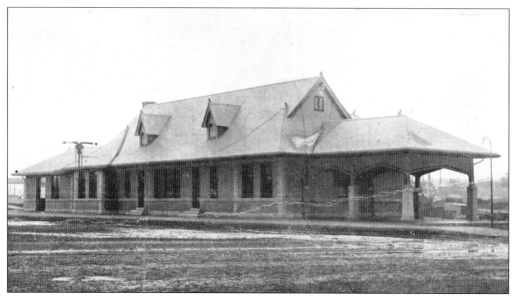

The postcard above is of the Chicago, St. Paul, Minneapolis, and Omaha Railway Company. It was on this railroad that the first "iron horse" arrived in Sioux Falls in 1878. The people knew that the railroad would greatly improve the city by bringing in new settlers with money and supplies.

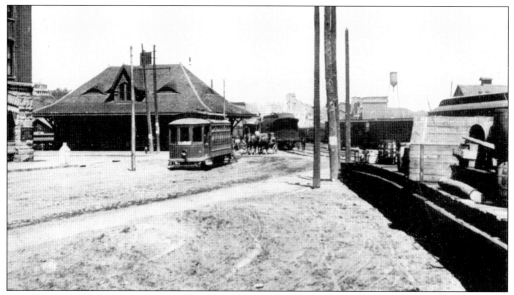

The Chicago, Milwaukee, St. Paul Railway Company, located on the northwest corner of Fifth Street and Phillips Avenue, arrived on December 18, 1879. In 1894, a passenger depot (on left) and a freight depot (loading dock on the right) were built near each other. The depot was discontinued in 1946 and currently is one of the sites of Southeastern Behavioral Health.

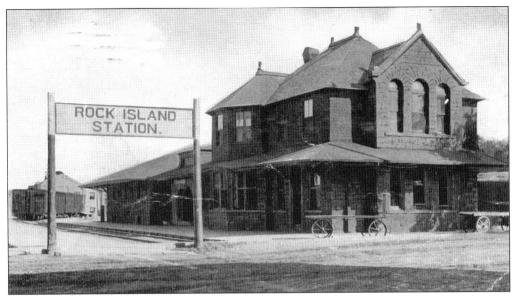

On October 26, 1886, the Burlington, Cedar Rapids, and Northern Railroad Depot was completed. The depot was later named Rock Island Station. The depot, located on the southeast corner of First Avenue and Tenth Street, was in use until 1970. The depot building was later used as the Burlington Restaurant and now is used by Midland National Life Insurance Company.

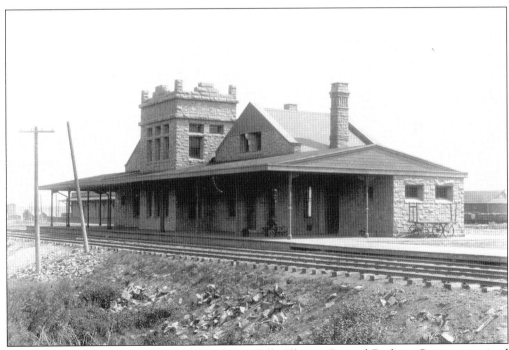

One of five major railway companies in Sioux Falls, Illinois Central Railway Company arrived on December 19, 1887. This railway was utilized for transporting the Sioux quartzite and for freight and passenger service beginning in 1888. This depot was built on the east side of the river between Tenth and Eighth Streets and still stands today.

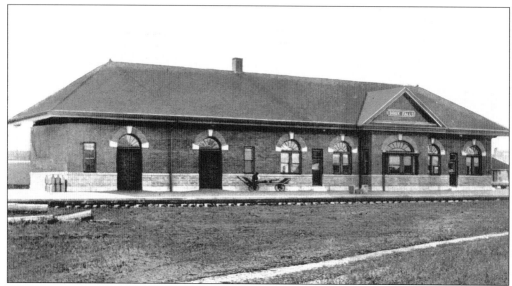

The Great Northern Railway Company (GNR), in 1888, absorbed the Sioux Falls Yankton and Southern Railway Company. In 1893, GNR absorbed South Sioux Falls Rapid Transit line and the South Sioux Falls to Yankton Railroad in that same year. The South Dakota Central Railway (Sioux Falls to Watertown) was also acquired by GNR in 1916, with the Central Railway beginning its service to Watertown in 1905. In 1970, GNR merged with Burlington and Santa Fe to form the Burlington Northern Santa Fe (BNSF) Railroad Company.

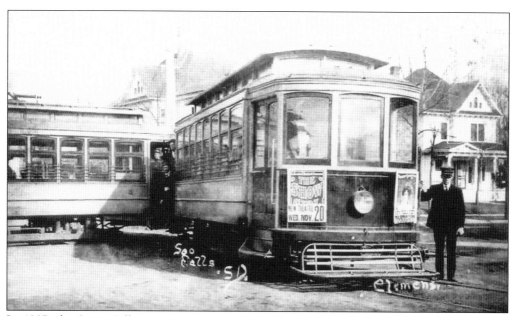

In 1907, the Sioux Falls Traction Company began and eventually rode 16 miles of tracks to provide transportation throughout Sioux Falls. It only cost 5¢ to ride these electric streetcars. The trolleys competed with the new form of transportation called the automobile. In 1929, the trolleys lost out to the automobile and were replaced by bus service.

Six

GOVERNMENT BUILDINGS

One rarely gets a chance to think about the history of the United States postal service. From letters written by homesteaders to tell their families they have arrived and settled in Sioux Falls, to delivery of packages purchased off the Internet, postal employees have served this country every step of the way. The postal service is an industry that has changed significantly from the incoming and outgoing mail being kept in cigar boxes in the Fort Dakota Barracks to the electronic sorters currently used throughout the city. Mail is still hand-delivered however. Although there had to be some form of mail distribution, there was no official post office until May 1, 1865, when the military established Fort Dakota. The first post office was established in the Fort Dakota Barracks until around 1872, when it moved briefly to a small building located near Ninth Street and Phillips Avenue before returning to the barracks in 1870. In 1872, the post office moved to the Pantograph building on the west side of Phillips Avenue, between Sixth and Seventh Streets. In 1873, the post office relocated again to a building near Eighth Street and Phillips Avenue, sharing space with the law firm of Winsor and Bippus. John Bippus presided over the post office at that time. Beginning in 1875, the post office was located in three different buildings owned by E. A. Sherman, the first located on the west side of Phillips Avenue between Eighth and Ninth Streets, the second on the northeast corner of Ninth Street and Phillips Avenue, and the third on the southwest corner of Ninth Street and Main Avenue. Until 1895, the post office relocations were within one to two blocks of each other. On May 18, 1895, the federal building, located on the southeast corner of Twelfth Street and Phillips Avenue, was completed, and the post office relocated there. During construction in 1911, it was temporarily relocated to the Paulton building, located on the southeast corner of Eleventh Street and Phillips Avenue. In 1966, the post office needed more space and the new post office was built on the east side of Second Avenue between Eleventh and Twelfth Streets, and several other post offices have been built. City delivery began in 1887; rural delivery began in 1904. On January 16, 1932, airmail began in Sioux Falls when the first airplane touched down at the Sioux Falls airport, located south of Forty-first Street and west of Western Avenue. In 1939, the airmail service was relocated to the new municipal airport, in its current location, in the north part of the city.

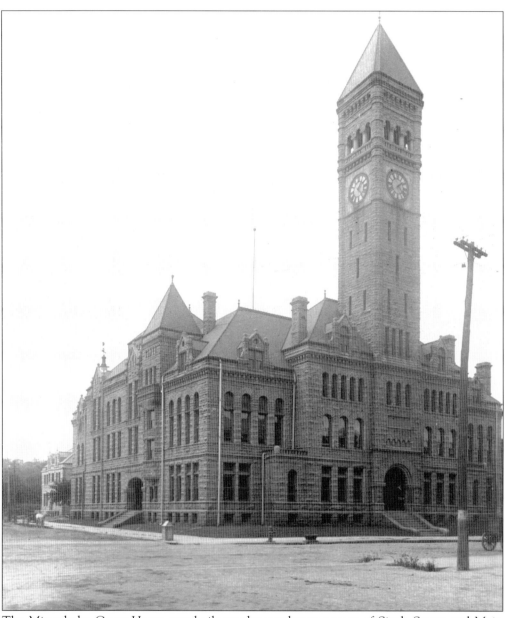

The Minnehaha Court House was built on the northwest corner of Sixth Street and Main Avenue in 1890. The clock in the bell tower was installed toward the end of 1892. An annex was built in 1937 to the north of the courthouse to provide space for more offices. The courthouse was restored and is now the Old Court House Museum, part of the Siouxland Heritage Museums organization.

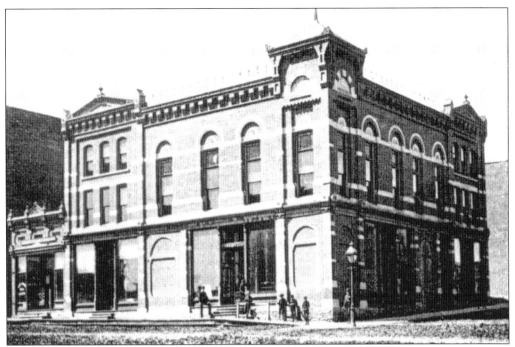

In July 1883, rooms for county offices and a courtroom were located in the Sherman building, located on the southwest corner of Main Avenue and Ninth Street where the Northwest Security National Bank building is now located. The Sherman building was used as the post office until 1895, when the new federal building and post office was built. In 1898, the Sherman building was renovated into the New Theatre and used until the building was razed in 1916.

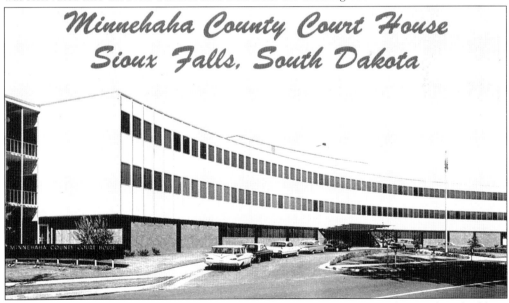

The new Minnehaha County Court House was completed in 1962. This modern building, located on the west side of Dakota Avenue between Fifth and Sixth streets, was designed with a night and day difference in appearance from the old courthouse, not more than a block away. The newest Minnehaha Court House, completed in 1996, is located north of this building.

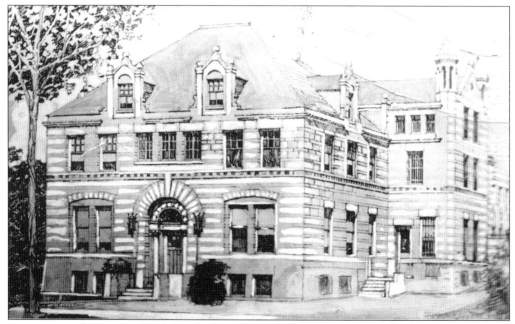

Construction began for this Minnehaha County Jail in 1911. Previously the county jail was located north of the Minnehaha County Courthouse where the courthouse annex was later built. The above jail was used until 1977, when the public safety building was completed. In 2003, a new 400-person jail was constructed north of the public safety building. This old building is now used by the Minnehaha County Extension Office.

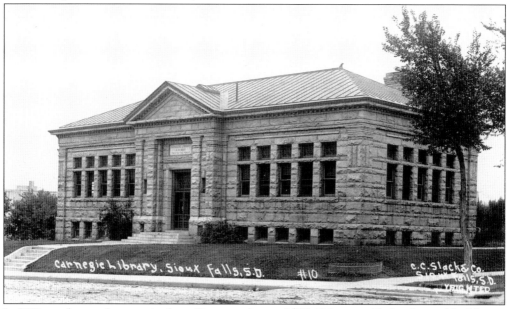

In 1901, steel manufacturer Andrew Carnegie donated $25,000 to establish a free public library. The library was in use at this location until 1972, when the downtown library was built. Located on the southeast corner of Tenth Street and Dakota Avenue, the Carnegie building has been in use by the Civic Fine Arts Association and is currently the Carnegie Town Hall, which houses the Sioux Falls City Council chambers and mayor's office.

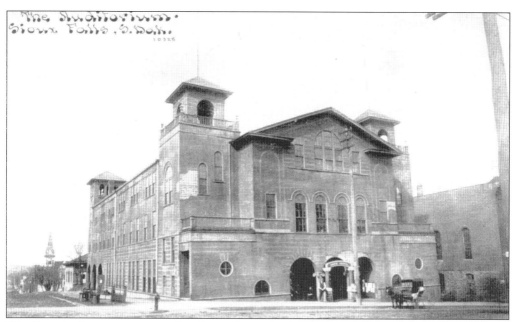

The City Auditorium was completed in 1899 at the location of the city hall building (seen in the picture below) on the northeast corner of Ninth Street and Dakota Avenue. The fire station was located in the basement on the northwest side. The bell in the bell tower was later moved to the Central Fire Station.

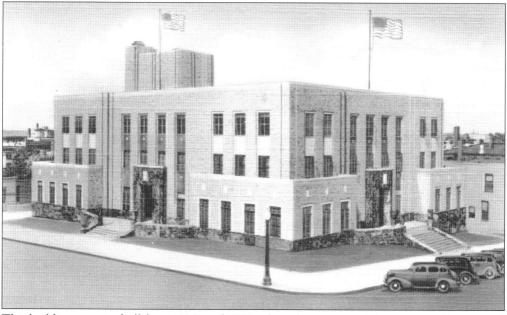

This building was city hall from 1936 until 2001, when the mayor and city council offices moved to the old Carnegie Library building now called Carnegie Town Hall. The City Auditorium and Germania Hall were on this location before. This building was a WPA project completed in 1936 for $432,000.

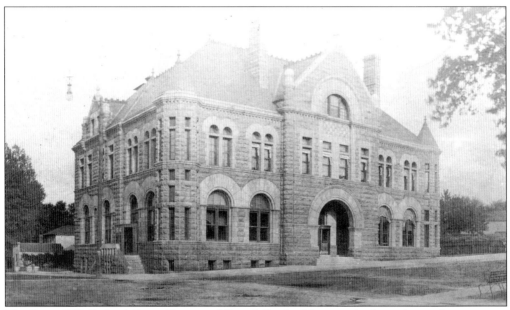

The Sioux Falls Federal Court House and Post Office building was built on the southeast corner of Twelfth Street and Phillips Avenue in 1895 and continues to provide space for federal courts and government offices.

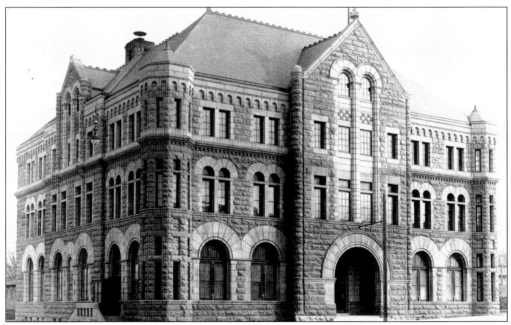

It takes a little time and a close eye to see how this building is different from the picture seen above. Compare the two buildings for a few moments and try to see what is different, and then continue reading to learn the changes. The structural changes include a total third floor added in 1913 and an east annex added in 1933.

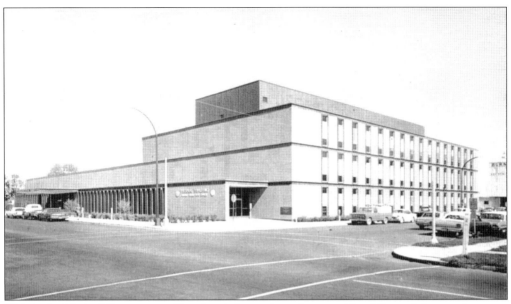

This is the United States post office that is located on the east side of Second Avenue between Eleventh Street and Twelfth Street. This building was completed in 1966 and replaced the old post office that was located in the current Sioux Falls Federal Court House building located on the east side of Phillips Avenue, between Twelfth and Thirteenth Streets.

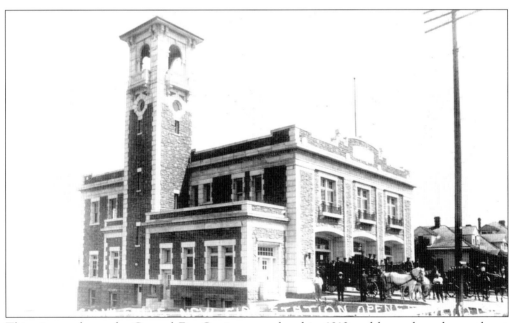

This picture shows the Central Fire Station, completed in 1912 and located on the southeast corner of Ninth Street and Minnesota Avenue. Previously the fire station was located in the northwest section of the City Auditorium. This building was originally constructed to store horses and horse-drawn equipment, which were used until 1917 when they were replaced by motorized vehicles. The horses were stored at ground level on the east side of the building. (Courtesy Mike Wiese.)

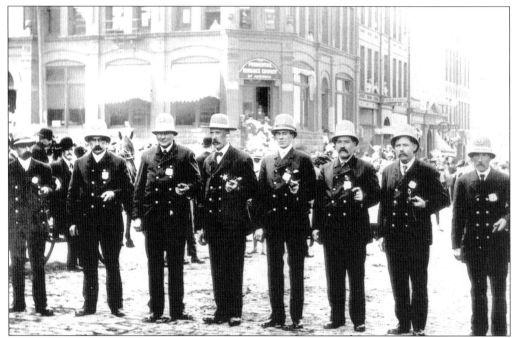

Pictured above are the members of the police department, as they looked in 1908. This photograph is looking north on Main Avenue from Ninth Street. The buildings are, from left to right, the Metropolitan Block (the Minnehaha National Bank), the Ramsey building, Argus Leader, and the GAR hall.

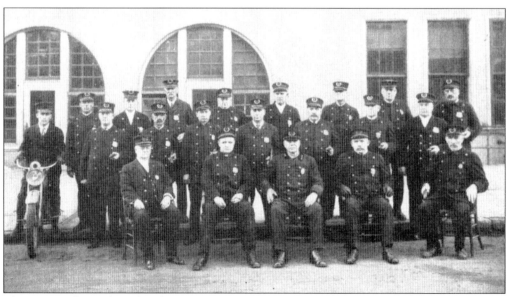

This picture shows the police department around 1916, standing in front of the City Auditorium located then at the northeast corner of Ninth Street and Dakota Avenue. W. H. Martin was the chief of police. In 1916, there were only two traffic officers.

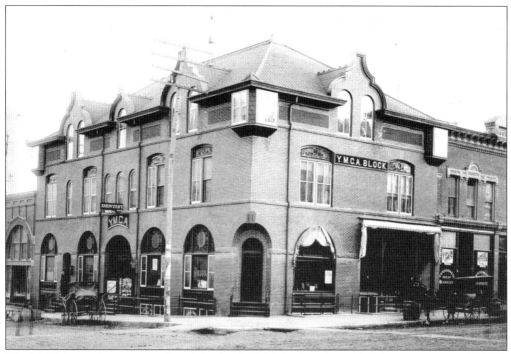

The YMCA was first organized on March 28, 1886. In October 1889, the organization became incorporated and on January 13, 1890, moved to the second floor of the YMCA building (E. G. Ledyard building), which was located on the southeast corner of Ninth Street and Main Avenue, where the Fantle Brothers' department store would later be located. (Courtesy Siouxland Heritage Museums, Sioux Falls.)

Hard times began in 1895, and the YMCA became inactive until January 1899. The organization moved to different buildings and disbanded for another short time but reorganized and became incorporated on August 18, 1919. This view shows the new YMCA building located on the northeast corner of Eleventh Street and Minnesota Avenue, which was dedicated on October 24, 1922. The YWCA organized in 1921, and a building was constructed in 1936 to the east.

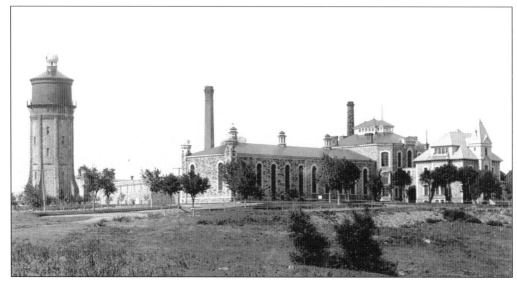

The South Dakota Penitentiary was completed in 1882. From 1905 to 1909, a shirt factory was in operation in the penitentiary. Beginning in 1926, license plates were made in the old shirt factory. Beginning around 1909, there was a twine binding plant that also operated out of the penitentiary. In 1939–1940, the west wing was remodeled. The warden's residence was built in 1884–1885 and the deputy warden's residence in 1888.

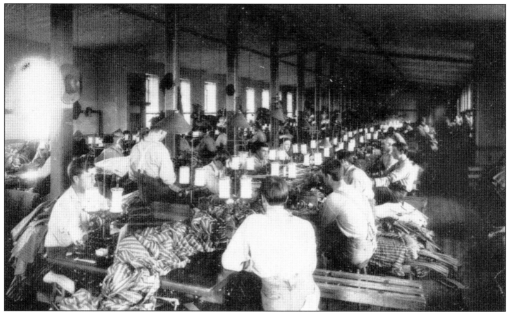

This picture shows the shirt factory inside the South Dakota Penitentiary. The industry lasted from 1905 to 1909. (Courtesy Mike Wiese.)

Seven

STREETS, BUILDINGS, AND MISCELLANEOUS

The streets of Sioux Falls have seen horses, cattle, people, bicycles, skateboards, wagons, tractors, cars, pickups, semitrucks, motorcycles, motorized scooters, and maybe even a canoe when some of the streets were flooded. The city is unique in the way that the streets and avenues are numbered. Most cities start with First Street or First Avenue as where the street numbers start. Sioux Falls begins its street numbering at Ninth Street and Phillips Avenue, where the Cataract Hotel was once located. Not only was the Cataract Hotel a common spot for business and social events, Phillips Avenue was also in close proximity to the river and railways, which made it easy for the exchange of goods.

In the late 1960s and early 1970s, the Sioux Falls downtown area was beginning to change significantly with the many large shopping malls being built south of town: Western Mall, built in 1968; Empire Mall, built in 1975; and New Town Mall (present day Empire East), built in 1980. These malls began pulling the downtown stores into the mall setting. Some of the stores that moved from downtown to the malls were Montgomery Ward, Fantle's, and J. C. Penney. This trend gradually spread out the stores and businesses of the downtown area, and people had less desire to shop and visit the downtown area. Vacant buildings were neglected, and the downtown area lost its appeal. Eventually there was encouragement by federal programs, including urban renewal, to clean up the downtown area and make way for new business. It is hard to know what the cost would have been if the downtown area and vacant buildings were left alone in hopes that someday someone would want to spend a lot of money to restore them. Most would agree that progress has a cost. Most would agree that the progress of Sioux Falls was worth the cost of the buildings that were razed because the decision to do so seemed right at the time. Most would also agree that whenever possible, historic buildings in the downtown area should be restored when future projects to develop the city are considered.

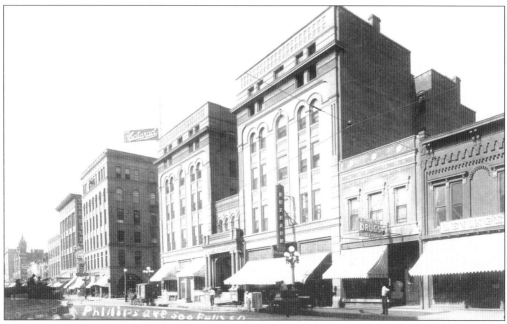

This view is looking south to the west side of the Phillips Avenue and Ninth Street intersection. The tall buildings are, from left to right, the Bee Hive Department Store, the Edmison-Jamison Office building, and the Cataract Hotel. Notice that there are both cars and horses with wagons on the street. To the far left, with a pointed tower, one can see the Masonic temple built in 1884.

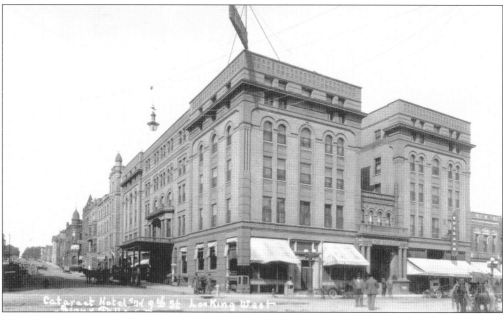

This view is looking west on Ninth Street from Phillips Avenue. This picture includes, from left to right, the Metropolitan Block (which has a large round peak), the Chicago House (later called the Lincoln Hotel), the Elks Club, Hollister-Beveridge building (which has a smaller round peak), and the Cataract Hotel. This picture is from the early 1900s.

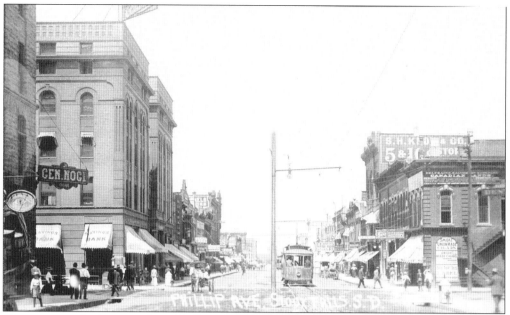

This picture is looking north on Phillips Avenue from Ninth Street. For reference, the Cataract Hotel is the twin building toward the left of the picture. Notice the electric streetcars that were a part of the Sioux Falls Traction Company. This company ran on 16 miles of tracks throughout the city from 1907 to 1929.

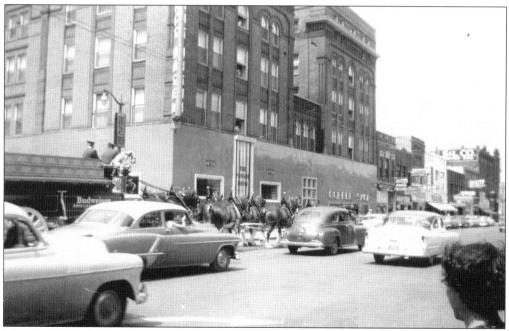

This is a view showing what appears to be a parade in the center of Sioux Falls in the 1950s. The parade is headed north on Phillips Avenue, crossing Ninth Street. The big building in the middle of the picture is the famous Cataract Hotel. Behind the cars is a Budweiser wagon pulled by Clydesdale horses.

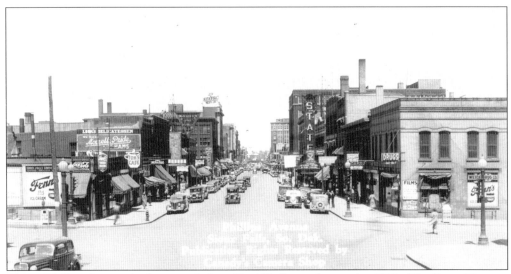

This is Phillips Avenue looking north from Twelfth Street during the 1930s. The State Theater, on the right side, opened in 1926 and was the largest theater in South Dakota for some time, seating up to 1,350 people. Currently money is being raised and work is being done to restore this beautiful theater.

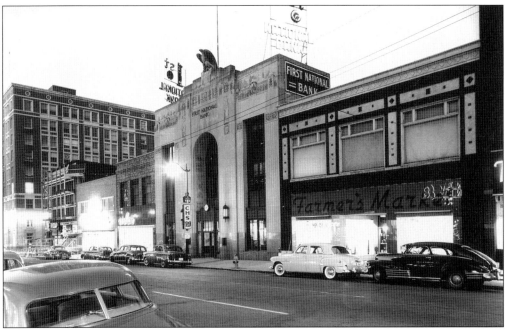

This photograph shows the First National Bank building constructed in 1929. First National Bank is the oldest bank in Sioux Falls, founded in 1885. This building was razed in 1976, after the new First National Bank building was constructed to the north, where it stands today. The eagle, on the top of the building, was saved and sits in front of the current bank building at Ninth Street and Phillips Avenue.

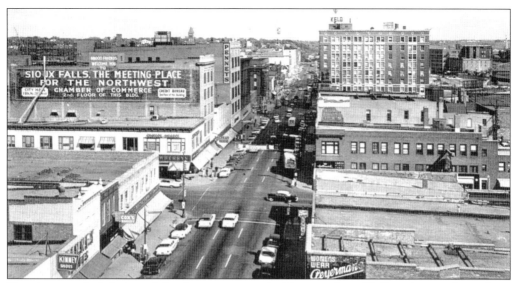

Here is a wonderful view of the downtown area looking north on Phillips Avenue from about Eleventh Street. The tallest building on the right side of the picture still stands today, in what was the center of Sioux Falls. The Sioux Falls National Bank building was constructed in 1917 and has continued throughout the years as a bank and office building.

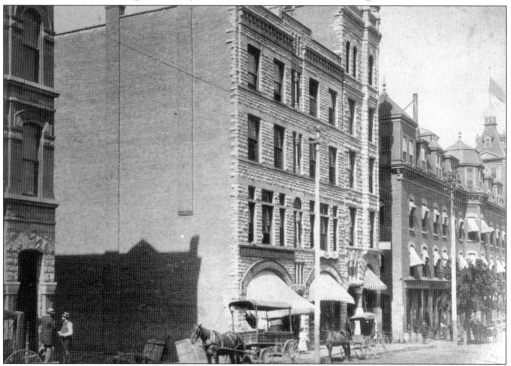

This view of Ninth Street looks east from Main Avenue. This photograph was taken before June 1900 when the Cataract Hotel, seen to the right in the picture, burned to the ground from fireworks igniting in the front window. Notice the Elks Club building had not yet been built in the space between the Chicago House on the left and the Hollister building on the right. (Courtesy Mark Thorstenson.)

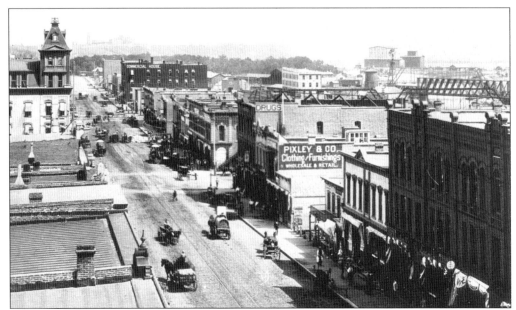

This is an early photograph taken around 1890 of Phillips Avenue looking north from Tenth Street. The tall building to the left was the Cataract Hotel. The building on the right is the Beach Pay building, which still stands today. In the distance, beyond the Commercial Hotel seen in the middle left, one can faintly see the South Dakota Penitentiary completed in 1882 on the hill. (Courtesy Mark Thorstenson.)

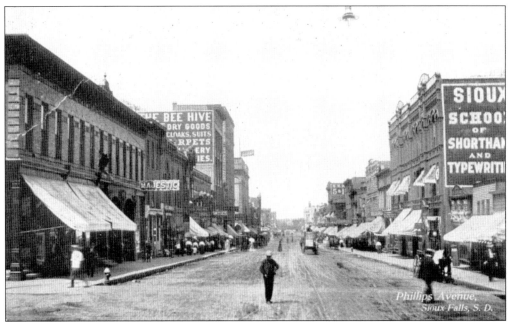

This postcard view of Phillips Avenue is looking north from Tenth Street. The building to the left was the C. K. Howard Store, near where the Phillips Avenue Diner is located today. Almost all of the buildings one can see in this picture have been torn down, with the exception of the Beach Pay building on the right with the Sioux School sign.

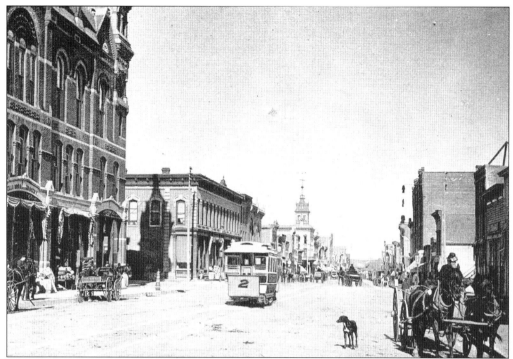

This photograph was taken around 1890 and shows Phillips Avenue looking north from about Eleventh Street. The large building to the left was the Masonic temple, built in 1884. One can see the top of the building as a shadow on the C. K. Howard Store, the next building to the right. In the middle of the photograph, one can see the Cataract Hotel. (Courtesy Mark Thorstenson.)

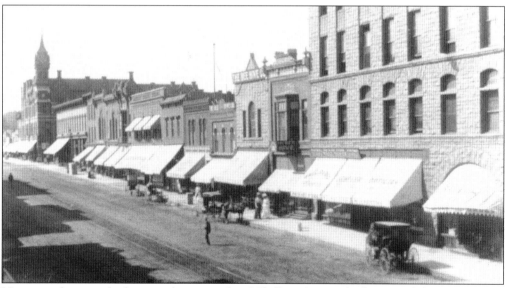

Here is a photograph showing the west side of Phillips Avenue looking south between Ninth and Tenth Streets with the Masonic temple to the far left. The building to the far right is the Edmison-Jamison building, completed in 1890. Also note the smaller Bee Hive Company building to the left of the Edmison-Jamison building. (Courtesy Mark Thorstenson.)

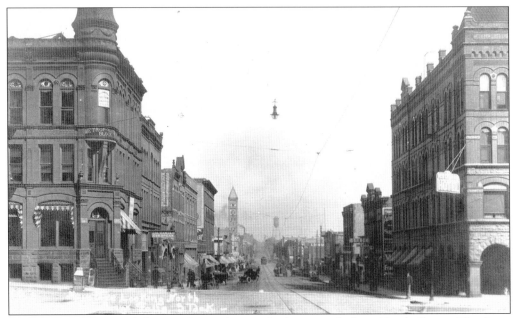

Seen here is a postcard showing Main Avenue looking north from Ninth Street. The large building to the left was the Metropolitan Block, built in 1886. The middle of the photograph shows the bell tower of the Minnehaha County Court House. The large building to the right was the Chicago House (later the Lincoln Hotel).

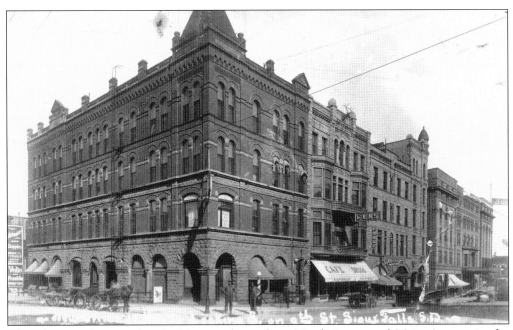

This photograph was taken looking northeast from Ninth Street and Main Avenue in the early 1900s. The buildings include, from left to right, the Chicago House, the Elks Club, Hollister-Beveridge, and the Cataract Hotel. The Hollister-Beveridge building was razed in 1956. The rest of the block was razed in 1973 as a part of urban renewal. The Wells Fargo Bank buildings are on this block today.

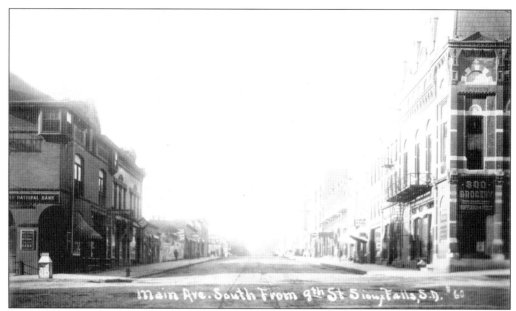

This is a photograph showing Main Avenue looking south from Ninth Street in the late 1890s. The YMCA block is seen on the left, and the New Theatre is on the right. After a remodeling, the New Theatre opened in the Sherman building in 1898. Previously the Sherman building provided space for the post office and county offices. The New Theatre was torn down in 1916 to make room for the N. W. Security Bank building, which stands today. (Courtesy Mike Wiese.)

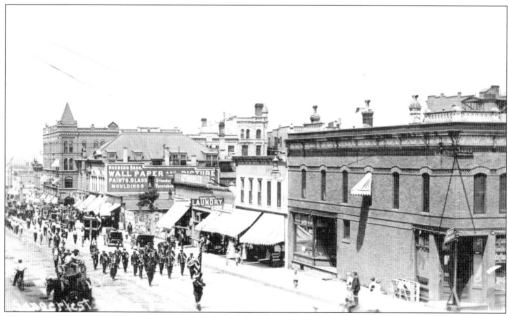

This view shows the Sangerfest Parade taking place on Main Avenue, with the band marching south between Ninth and Tenth Streets. The Norberg Brothers store was located in the building south of the YMCA block. One can see the Norberg Brothers store sign on the side of the building in the middle left of the picture. Today's Norberg Paints has been in business since 1885.

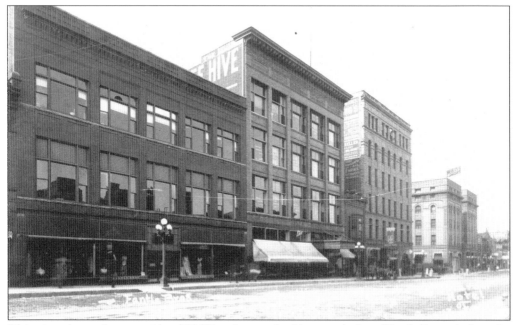

This view shows the west side of Phillips Avenue looking north from Tenth Street before the Fantle Store fire in 1918. The buildings are, from left to right, Fantle Brothers Department Store, Beehive Department Store, Edmison-Jamison building, and the Cataract Hotel. This postcard view is from the early 1900s.

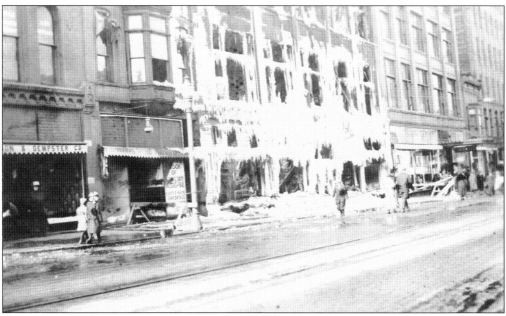

On a cold day, February 3, 1918, the Fantle Brothers Department Store was destroyed by fire. The store was rebuilt in the same location, the west side of Phillips Avenue between Ninth and Tenth Streets (the white building seen in the top picture on the next page). In 1939, Fantle Brothers Department Store moved again to the southeast corner of Ninth Street and Main Avenue.

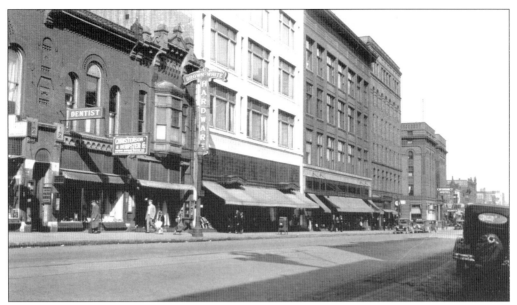

Seen here is a photograph from the late 1920s showing the west side of Phillips Avenue looking north from Tenth Street after the new Fantle Brothers Department Store building was constructed. The large buildings are, from left to right, the Fantle Brothers Department Store (later J. C. Penney), Bee Hive Department Store (later Montgomery Ward), Edmison-Jamison building (later the Minnehaha building), and last, the Cataract Hotel.

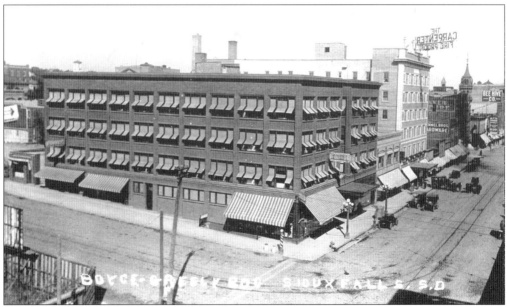

This postcard view is looking northwest from on top of the Paulton building, located on the southeast corner of Eleventh Street and Phillips Avenue. The Boyce Greeley building, completed in 1910, is the building to the left with all of the awnings. The Carpenter Hotel, completed in 1912 is the building to the right with its sign on the roof. In the distance is the pointed Masonic temple, completed in 1884.

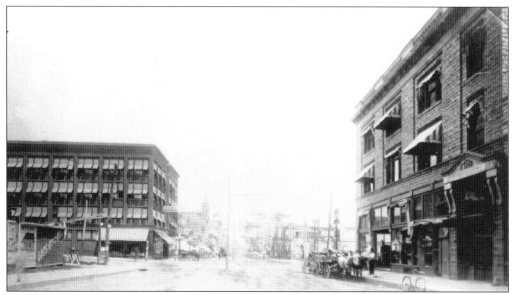

This picture is of Eleventh Street and Phillips Avenue looking north, taken after the Boyce Greeley building was completed in 1910 and before the Carpenter Hotel was built in 1912. The building to the right is the Paulton building, later known as the Hanson building. The picture below shows the front of the Paulton building.

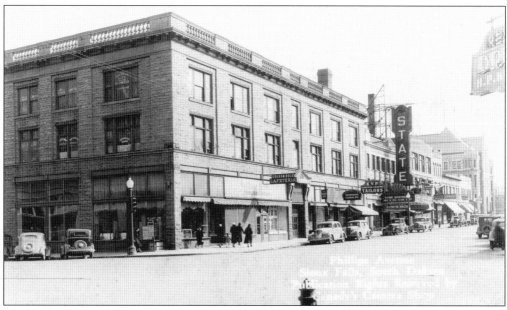

This is Phillips Avenue, looking southeast from Eleventh Street, as it looked in the 1930s. The Paulton building, on the left, was built in 1906 and destroyed by fire in 1991. The State Theatre, to the right of the Paulton building, was completed in 1926, and renovations have begun for this beautiful theater. The Sioux Falls Federal Court House is to the far right. (Courtesy Mike Wiese.)

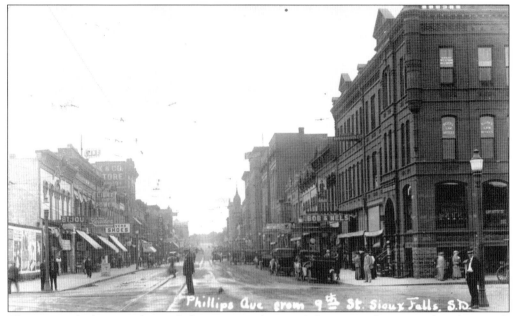

This view is looking south on Phillips Avenue from Eighth Street. The postcard reads, "Ninth St.," but Ninth Street is one block south, where the famous Cataract Hotel is located in the middle of the picture on the right. The large building on the right was the VanEps building, built in 1886. A large addition was constructed to the south in 1889. The building was razed in 1969.

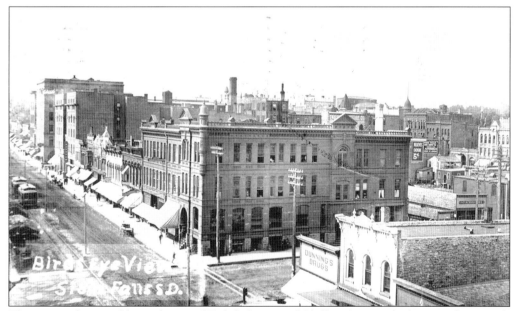

This postcard is an additional view of Eighth Street and Phillips Avenue, looking southwest with the large VanEps building in the center of the picture. Dunning's Drugs can be seen toward the bottom right of the picture. The picture on the next page shows a closer view of Dunning's Drugs.

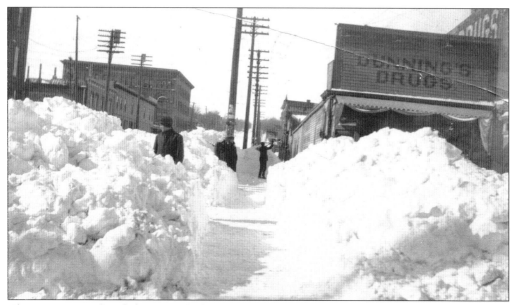

This is a view of Eighth Street looking west from Phillips Avenue, where today the south end of the downtown Holiday Inn parking lot is located. The right side of the picture shows the Dunning's Drugs after a record-breaking snowstorm in 1909. Lyman T. Dunning, pioneer druggist, owned and operated Dunning's Drugs from 1873 to 1920. The above building was razed in 1946.

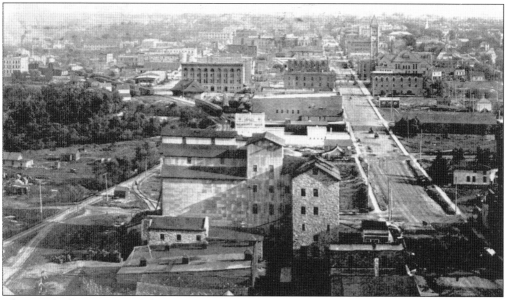

This is a bird's-eye view of downtown, looking south on Main Avenue from the hill on north Main Avenue. The buildings in the center of the photograph are the Sioux Falls Malting Works. The bell tower of the Minnehaha County Court House can be seen looking up Main Avenue and to the right of the picture.

Here is Phillips Avenue looking south from Seventeenth Street. To the right of the picture is the east edge of All Saint's School Campus. To the left are early houses, most of which still stand. Toward the center of the picture, to the right of the tree, is a small granite pillar, which was used as a hitching post to tie up horses. Hitching posts can still be seen in historic districts.

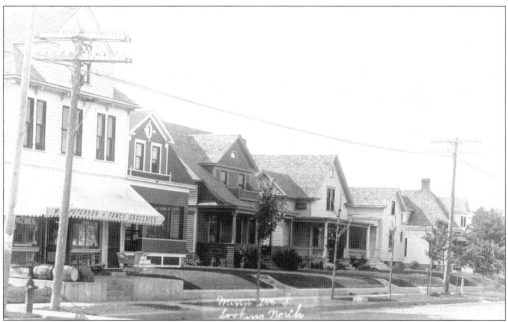

This photograph shows the west side of Minnesota Avenue looking north from Eighteenth Street. The building to the left was the W. E. Peterson Grocery Store located where Taco Bell now stands. Neighborhood grocery stores were common for many years, until supermarkets began and provided more options and more competitive prices.

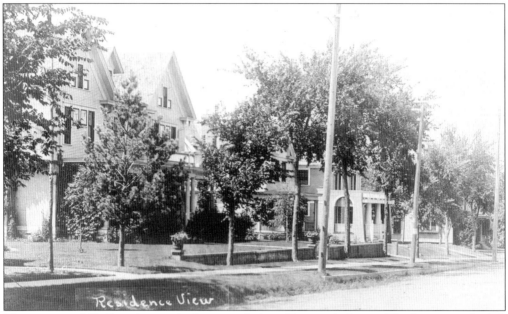

Residence View

This view is of Phillips Avenue looking north from Twentieth Street. The house on the left was the Glidden House built in 1900 at 1109 South Phillips Avenue. This house was built as a duplex for Daniel and Josephine Glidden and her parents to live in. Josephine was instrumental in establishing the Carnegie Library, now Carnegie Town Hall, by donating land and securing up to 4,000 books.

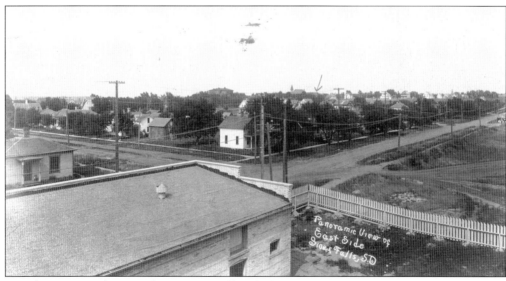

Panoramic View of East Side Sioux Falls, S.D.

Seen here is an early view of East Sioux Falls, which was a separate community from the city of Sioux Falls. East Sioux Falls was populated by families whose men worked in the east quarries. In 1904, four quarries were in operation to unearth and shape the purple jasper for building stones and paving blocks. Many of today's historic buildings were made of purple jasper.

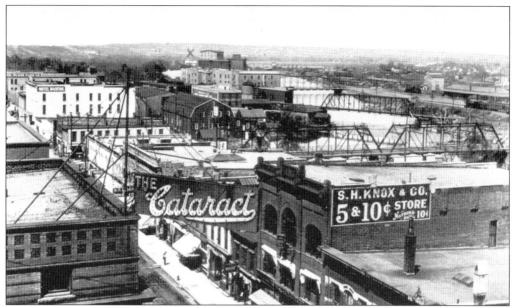

Here is a neat view of the downtown area, looking northeast from the top of the Edmison-Jamison building at Phillips Avenue and Ninth Street. The Eighth Street Bridge can be seen in the middle-right of the picture. In the distance on the left is the Hotel Dacotah, and further is the Rock Island Plow Company.

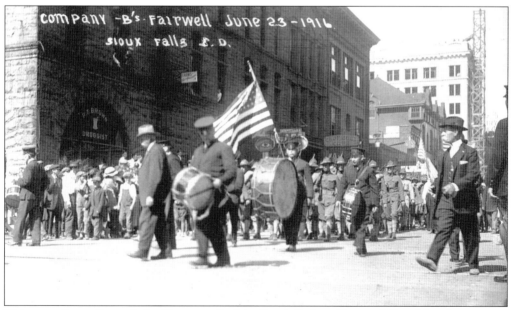

This was a farewell parade for Company B of the South Dakota National Guard for what appears to be the Mexican Border Expedition in 1916. Gen. John Pershing led a retaliation expedition against Gen. Francisco "Pancho" Villa in response to Villa's raid in Columbus, New Mexico. The following year, on April 6, 1917, the United States declared war on Germany and the United States entered World War I.

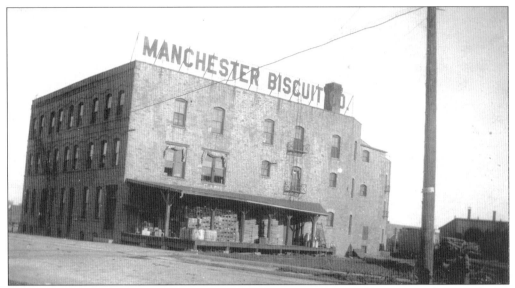

L. D. Manchester began the Manchester Biscuit Company in Sioux Falls in 1902. The Manchester Biscuit Company started small, as seen in the picture above, after the first addition in 1909. With time, there were several additions. Eventually two large additions were built, replacing part of the original structure. The original part of the building can be seen on the left side of the picture below. (Courtesy Raven Industries.)

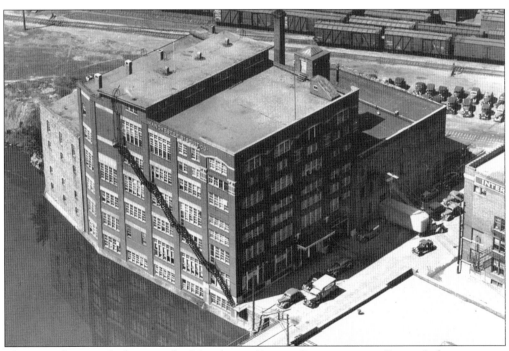

This is a photograph showing the Manchester Biscuit Company, now Raven Industries since 1961. This picture was taken in the 1930s, looking southwest. It is hard to believe that Sixth Street still passes between the Manchester Biscuit Company building and the International Harvester building. (Courtesy Raven Industries.)

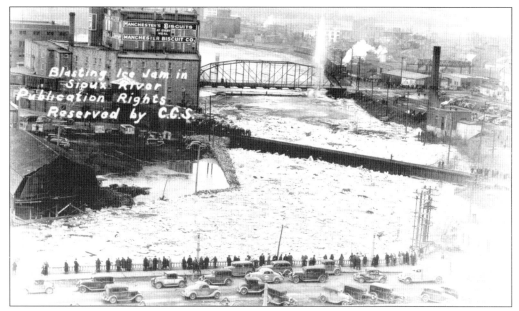

This neat picture from the early 1930s shows an ice jam on the Sioux River, looking north from Eighth Street. The Manchester Biscuit Company is seen in the upper left corner. The lower part of the Manchester building was the original section, and the taller part, with the "Manchester Biscuit Co." lettering, was the massive addition. (Courtesy Rick Castardo.)

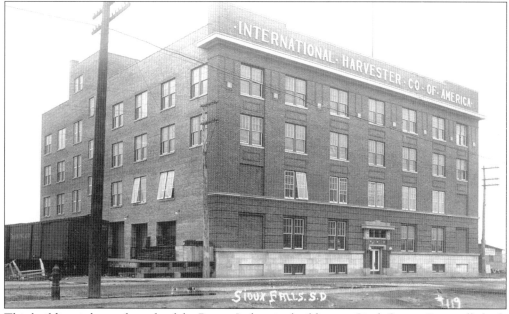

This building is located north of the Raven Industries building on Sixth Street. Originally built as the International Harvester Company, a farm machinery warehouse, the building is now called the Harvester and has been renovated to include loft apartments, Riverwalk Café, and Artisan House Galleries.

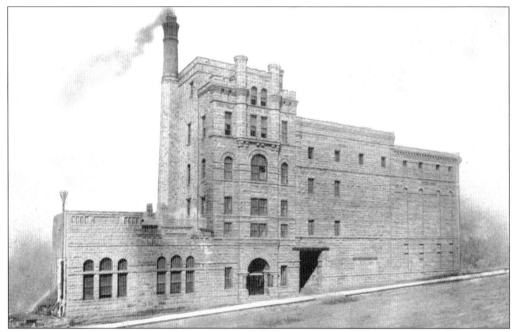

The brewery in Sioux Falls has had different names: 1875–1883, G. A. Knott and Company; 1883–1898, Sioux Falls Brewing Company; 1898–1912, Sioux Falls Brewing Company and Malting Company; and 1912–1919, the Sioux Falls Brewing Company. The above picture shows the brewery building, built in 1904. On October 10, 1987, the beautiful building was destroyed by fire.

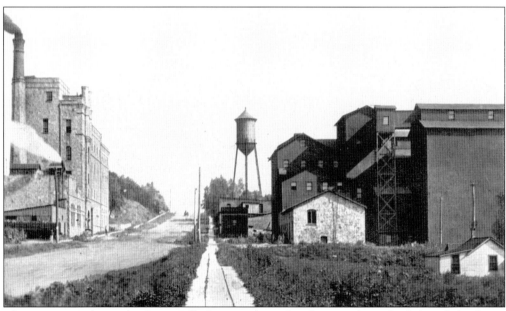

This neat view shows the Sioux Falls Brewery (completed in 1904) on the left and the Sioux Falls Malting Works (completed in 1902) on the right. From 1919 to 1933, Prohibition made the manufacturing, selling, or transporting of alcohol illegal. Prohibition resulted in the proliferation of organized crime in bigger cities. (Courtesy Mike Wiese.)

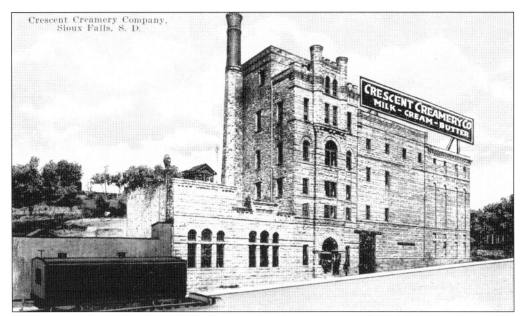

This picture shows the Sioux Falls Brewery building constructed in 1904. The Sioux Falls Brewery continued in this location until 1919, when the company was forced to close due to Prohibition. Beginning in 1919, the building was purchased by Crescent Creamery Company. From 1953 to 1974, Foremost Dairy Incorporated operated out of the building.

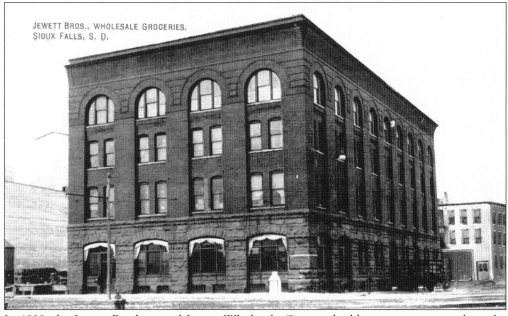

In 1899, the Jewett Brothers and Jewett Wholesale Grocery building was constructed on the southwest corner of Fifth Street and Phillips Avenue where it stands today. Comparing this postcard with the present-day building, one would notice there was an addition built on the south end of the building. Done in 1909, the addition was integrated so well that the whole building looks original.

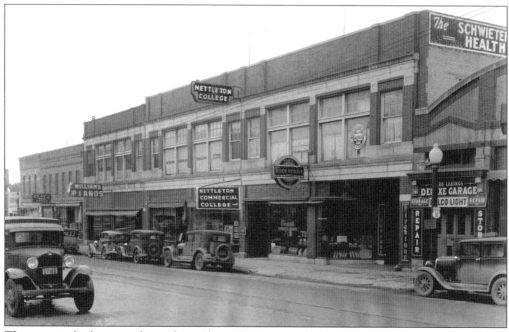

This view is looking northeast from Eleventh Street and Phillips Avenue. The main building in the center of the picture was Nettleton College. There were also offices in this building, including the clinic of Dr. A. W. Schwietert, chiropractor. The farthest left building was the Ballard and Son Monument Company. Looking at the north side of the Ballard and Son Monument Company building, one can still see the lettering of the original space.

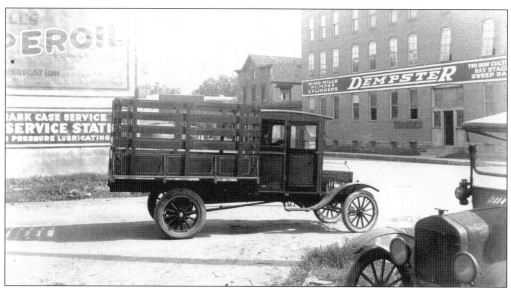

An early delivery truck is parked outside the Dempster Mill Manufacturing building at 434 North Main Avenue. This building was also used by Larson Hardware for many years. This could be the most colorful building currently downtown with the exterior painted red, yellow, and green.

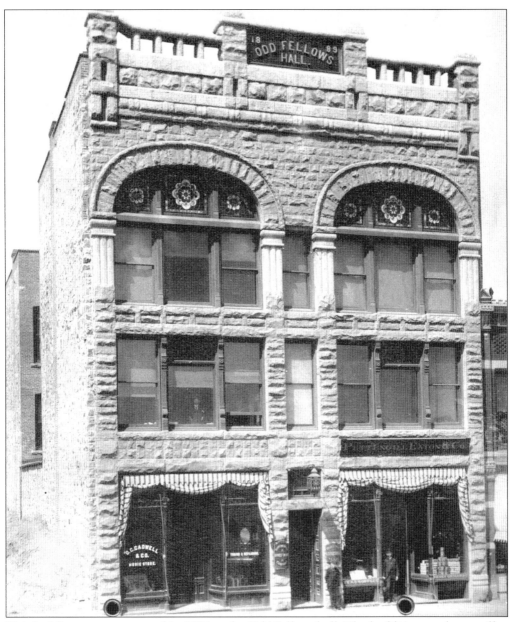

This building was constructed in 1889 as the Odd Fellows hall. The building was also an office for Sioux Falls pioneer R. F. Pettigrew. Pettigrew was South Dakota's first full-term United States senator. Pettigrew was one of the most outspoken advocates, locally and nationally, for the growth of Sioux Falls. This building was constructed with the Sioux Falls quartzite. This continues to be a very attractive building, located in the middle of the block on the west side of Main Avenue between Ninth and Tenth Streets. (Courtesy Siouxland Heritage Museums, Sioux Falls.)

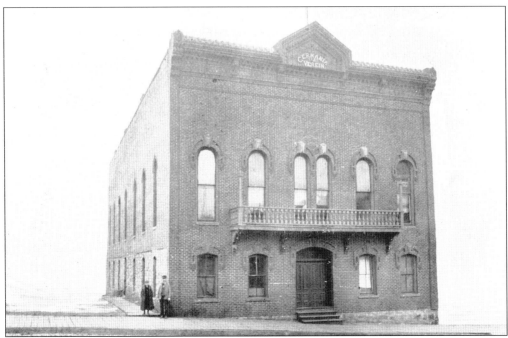

The above picture shows Germania Hall, built in 1880, on the north side of Ninth Street in the middle of the block between Main and Dakota Avenues. Germania Hall was used for live theater and conventions, prior to the City Auditorium being built to the west of the building in 1899. Both the City Auditorium and Germania Hall were razed in 1934–1935 in order to build city hall.

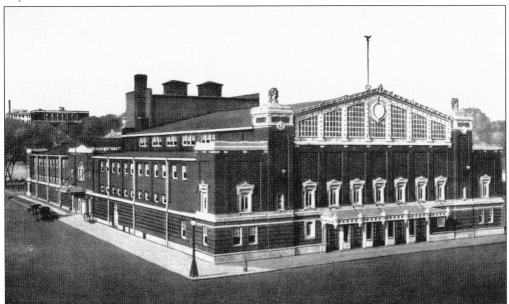

The Coliseum, built in 1917 on the northwest corner of Fifth Street and Main Avenue, replaced the City Auditorium. There was a large annex built in 1932, which was destroyed by fire on January 5, 1973. The roof collapsed in the Coliseum on February 18, 1994, only hours before a children's program was to begin.

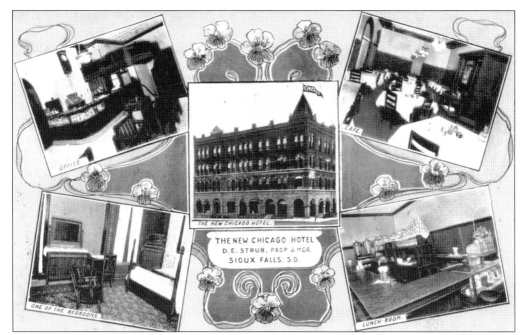

The New Chicago Hotel was located on the northeast corner of Main Avenue and Ninth Street. This was a large hotel and later became the Lincoln Hotel. This building was destroyed in 1973, during the urban renewal years. Presently one of the Wells Fargo Bank buildings is located on this block. Originally the building was called the Chicago House.

This picture shows an early record store with several phonographs for sale. In the postcard, the units are referred to as "Talking Machines." (Courtesy Mike Wiese.)

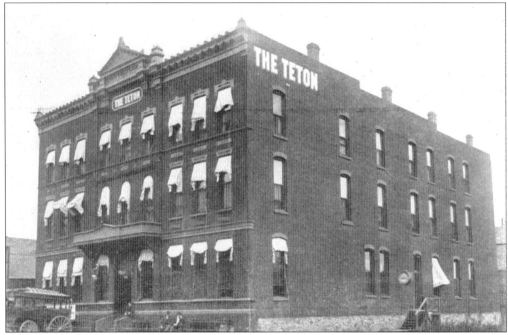

The Teton Hotel was located at 214–218 North Phillips Avenue, between Sixth and Eighth Streets. There were two Commercial Hotels located in this same location. This building was constructed in 1884, after the original Commercial House burned down. The Teton Hotel was razed in 1939. Soon after, the Hollywood Theatre was built by L. D. Miller, founder of Miller Funeral Home.

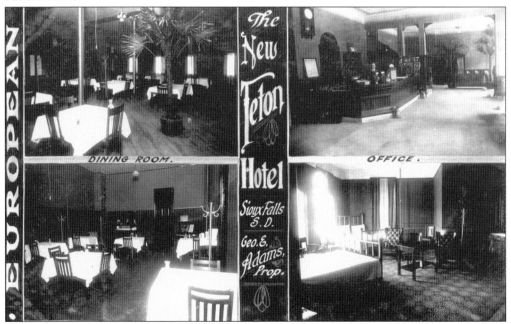

Originally the Teton Hotel was the Commercial House. The building was located where the Hollywood Theatre proudly stood for many years and where the Commerce Center building stands today. The downtown Holiday Inn is located directly west of where the Teton Hotel was located.

Dickenson's Café and Bakery was located on the west side of Phillips Avenue, between Tenth and Eleventh Streets. R. W. Dickenson was born in England and came to Sioux Falls in 1888 with a history of being a master baker. He had four sons who continued the business after Dickenson died in 1916. The bakery closed in the early 1950s.

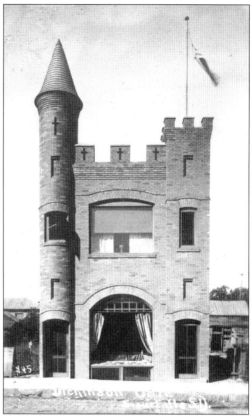

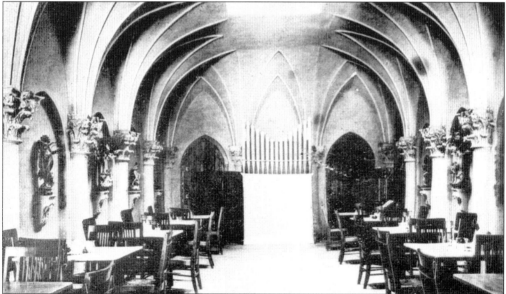

This picture shows the inside of the Dickenson Café and Bakery. Dickenson was unique and also thought to be a psychic. He had an interesting sense of architecture—his home had no square corners, and his café was shaped like a castle. The café was often referred to as "the Katzenjammer Castle."

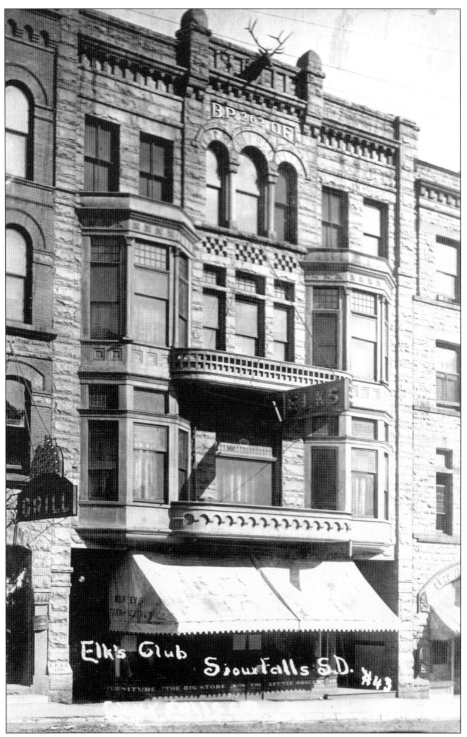

The Elks Club building began construction in 1901 and was completed in 1902. The Elks Club building was the last building to be constructed on the north side of the Ninth Street between Phillips and Main Avenues.

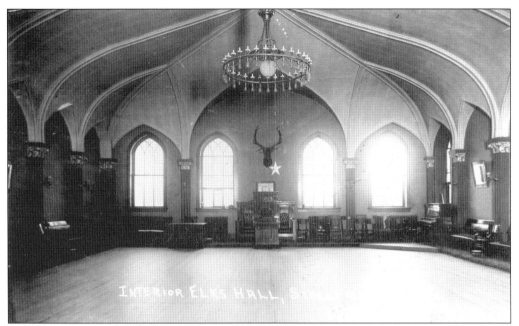

These pictures show the inside of the Elks hall of Lodge 262 of the Benevolent Protective Order of Elks. This Elks Club was organized on May 6, 1893.

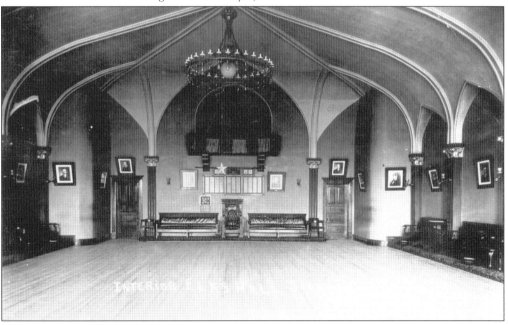

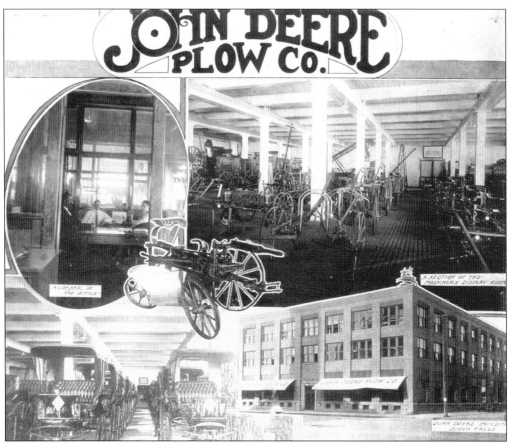

The John Deere Plow Company was located in the current Gourley building on the northeast corner of Main Avenue and Sixth Street, east of the Old Court House Museum. The implement dealer began in Sioux Falls in 1900. The building was restored wonderfully and today houses the Firehouse Coffee Shop in the basement, a furniture store on the main floor, and loft apartments in the upper floors. Below is a close-up view of the John Deere Plow Company. (Courtesy Mark Thorstenson.)

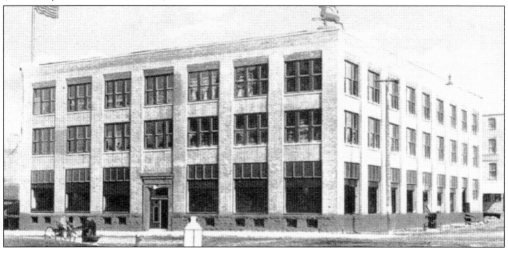

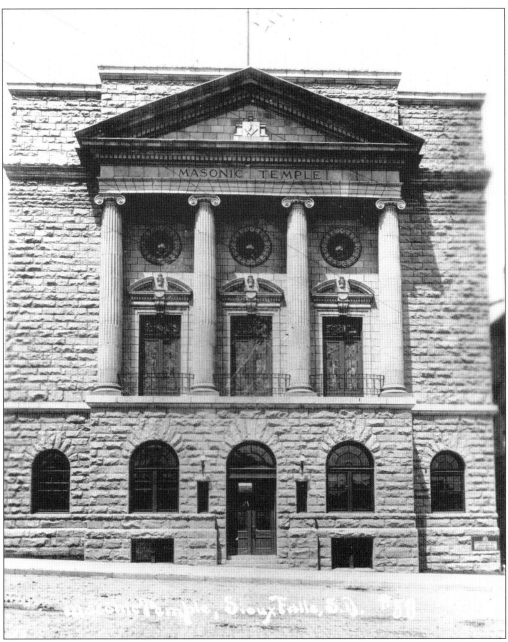

This Masonic temple building was constructed in 1905 and replaced the previous Masonic temple, which was located on the southwest corner of Tenth Street and Phillips Avenue. There was a fire in the upper floors of the Masonic temple building on May 2, 1956. This beautiful building was located on the north side of Tenth Street between Main and Dakota Avenues. There was a Masonic Grand Lodge Office and Library built at 415 South Main Avenue, which today is the office for Architecture Incorporated. The Masonic Grand Lodge Office and Library was completed in 1925 and continues to be a stunning building. Today the Masonic temple is located on the northeast corner of Fourteenth Street and First Avenue.

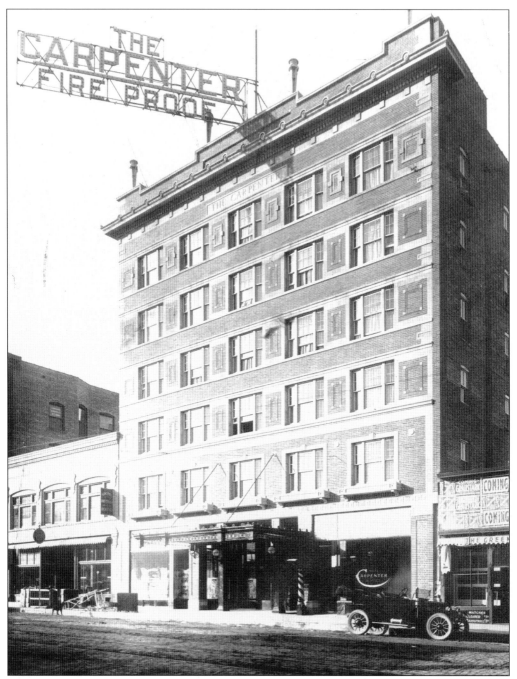

The Carpenter Hotel was built in 1912 by Mrs. C. C. Carpenter. After the Cataract Hotel fire, the owners of the Carpenter Hotel wanted to promote that they were fireproof by adding a "Fire Proof" sign to their roof. The hotel was later sold to Eugene C. Eppley of Omaha and again sold with the Cataract Hotel to the Sheraton Corporation of America on May 31, 1956, to become the Sheraton Carpenter Hotel. In 1962, remodeling converted the Carpenter Hotel into a new style called a "tourist class," or Sherwyn. The WFAT radio station broadcasted from the top floor of the hotel beginning in May 1922.

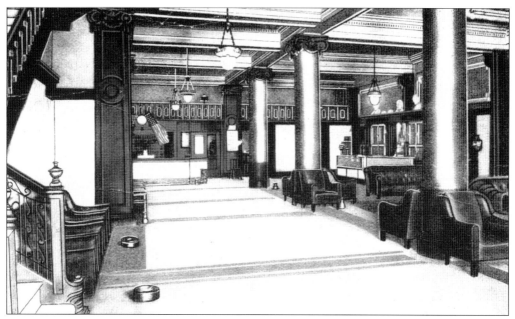

This shows the interior of the Carpenter Hotel located on the west side of Phillips Avenue between Tenth and Eleventh Streets. The Carpenter Hotel building today contains retail and commercial spaces. The lobby area in this picture has recently been renovated.

It is unclear where the café was located in the Carpenter Hotel. Seeing the interior of the hotel today, one can get a feel how it would have been for early Sioux Falls guests to stay in such a beautiful hotel with the beautiful woodwork and marble construction. This hotel had to compete for patronage with the famous Cataract Hotel, located one block away.

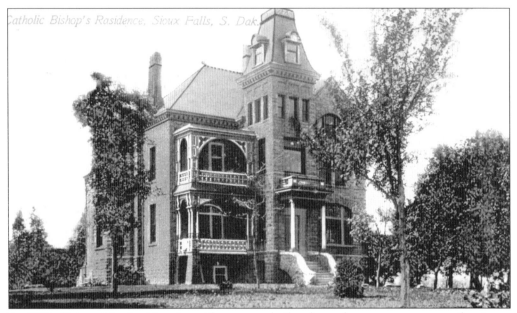

In 1890, Bishop Martin Marty's residence was built where the emergency room for Avera McKennan Hospital is now located. After Bishop Marty, Bishop Thomas O'Gorman resided in this house until his death in 1921. The house was razed in 1973 to allow McKennan Hospital to expand. It was Bishop O'Gorman's dream to build a cathedral. This occurred when St. Joseph's Cathedral was dedicated on May 7, 1919.

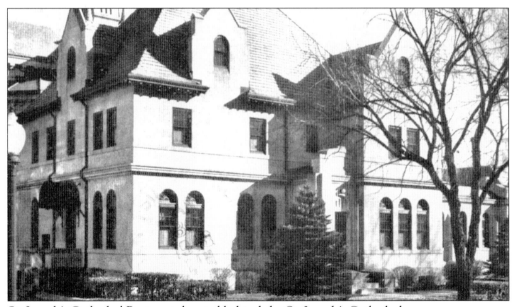

St. Joseph's Cathedral Rectory is located behind the St. Joseph's Cathedral.

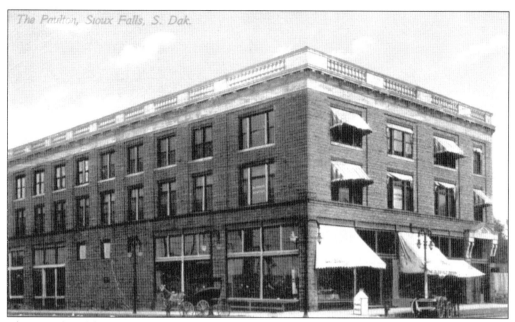

The Paulton, Sioux Falls, S. Dak.

This wonderful building was located on the southeast corner of Eleventh Street and Phillips Avenue. The Paulton building was constructed in 1906 and used for offices and retail stores. In 1910, the building was expanded to the south. The picture below shows the addition.

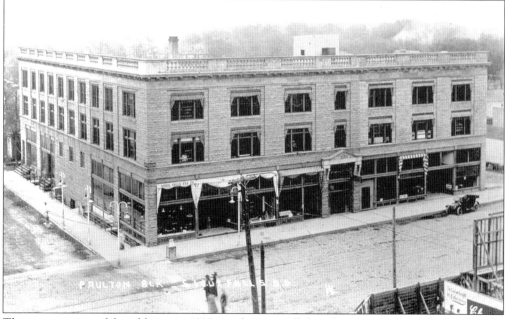

The construction of the addition in 1910 was done so well that the new south part looked like the original building. The Paulton building was later called the Hanson building and was destroyed by fire on May 25, 1991. The bottom right of the picture shows where Minerva's Restaurant is currently located.

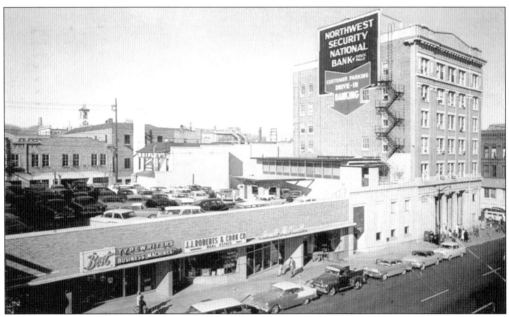

The Northwest Security National Bank building was built on the southwest corner of Ninth Street and Main Avenue. This bank was robbed on March 6, 1934. It is thought that John Dillinger and his gang were the robbers. The six men who held up the bank stole $46,000 and were never found or charged for the robbery.

A group of workers stand outside the Brooks building located on the northeast corner of Tenth Street and Dakota Avenue. Some of the businesses in the building included the Bell Paper Box Company, Fischer Printing Company, New Motor-Inn Chandler Company, and Robinson Motor Company. Today the building is the Carnegie Luxury Loft Apartments.

This shows the second and current location of the *Argus Leader* newspaper. Before this location, the Argus Leader newspaper building was located on the west side of Main Avenue, between Ninth and Eighth Streets until 1951, when the building was destroyed by fire. In 1887, the Argus Leader Publishing Company was formed when the *Sioux Falls Argus* and the *Weekly Leader* newspapers combined.

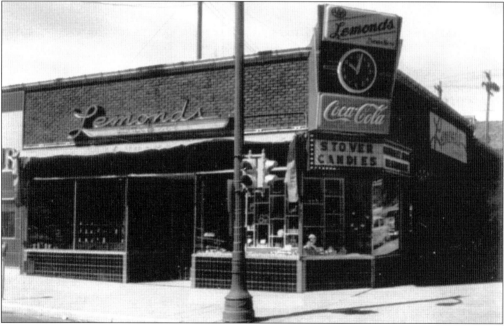

Lemonds Café was located on the southwest corner of Eleventh Street and Phillips Avenue. The businesses that have been at this location are, in order, Minerva's Confectionary, the Palace of Sweets, Lemonds Café, Peanut Gallery, and in 1977, Minerva's Restaurant. Minerva's Restaurant continues to be one of the finest and favorite restaurants in Sioux Falls.

This apartment building still stands on the southwest corner of Twelfth Street and Phillips Avenue, west of the Sioux Falls Federal Court House building. The Brown apartment building is named after Thomas H. Brown, who had the building built. Brown arrived in Sioux Falls in 1872. In 1889, he went into business with Eugene Saenger, and the company of Brown and Saenger has continued in business since.

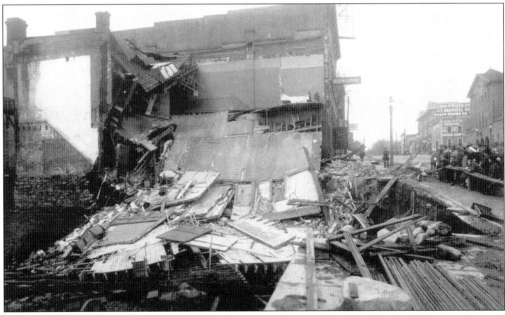

This picture shows the Shipley's building after it was destroyed by fire. The building was located at 213 West Ninth Street. (Courtesy Mark Thorstenson.)

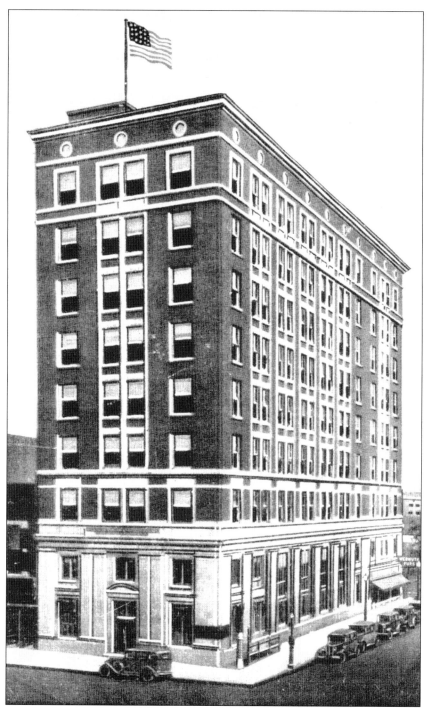

This famous bank and office building is the only remaining structure of the four corners of the center of the city on the northeast corner of Ninth Street and Phillips Avenue. When this building was built in 1917, the Cataract Hotel stood on the west corner. This building was also known as the Citizens National Bank, the National Bank of South Dakota, Western Bank, Security Bank building, and today the Great Western Centre.

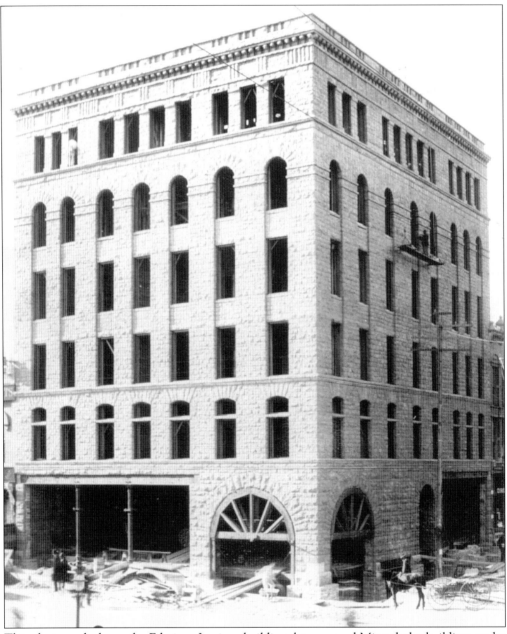

This photograph shows the Edmison-Jamison building, later named Minnehaha building, under construction in 1890. This building was located on the southwest corner of Ninth Street and Phillips Avenue and was designed by the famous Sioux Falls architect W. L. Dow. The upper four floors were removed in 1947, and the building was razed in 1980. (Courtesy Mark Thorstenson.)

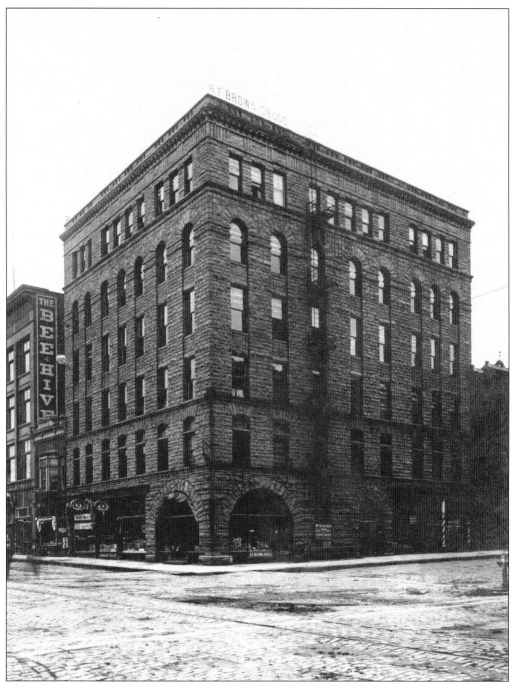

The Edmison-Jamison building was constructed on the southwest corner of Ninth Street and Phillips Avenue. This was a large office building used primarily by attorneys. Attorneys enjoyed the close proximity of their clients who were staying in the Cataract Hotel to get residency status for a quick divorce. South Dakota had one of the shortest time limits for getting a divorce, and people from all over would travel to and stay in Sioux Falls just to get divorced.

A shopping landmark for downtown Sioux Falls, the Shriver-Johnson Department Store was built in 1918. Today the building stands proudly as it continues to house Sioux Falls businesses. J. H. Johnson and A. R. Shriver were the founders of the Shriver-Johnson Company.

This postcard shows the interior of the All Saints School around the early 1900s. The rooms included are the library, parlor, and music room. There are many historical items and pictures in the renovated rooms of the All Saints School building.

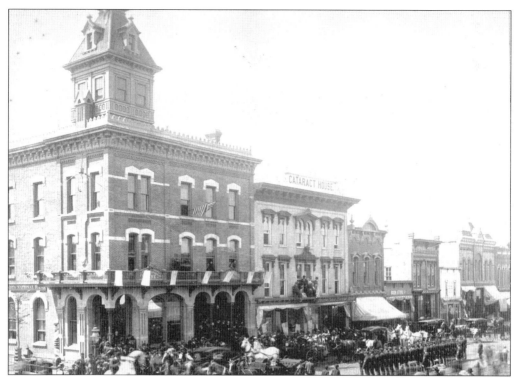

For 101 years and within three different buildings, the Cataract Hotel stood on the northwest corner of Ninth Street and Phillips Avenue. The Cataract Hotel was such a social center that the intersection where it was located became the center of town and where the street and avenue numbering began. This shows the second of the three Cataract buildings before it was destroyed by fire on June 30, 1900.

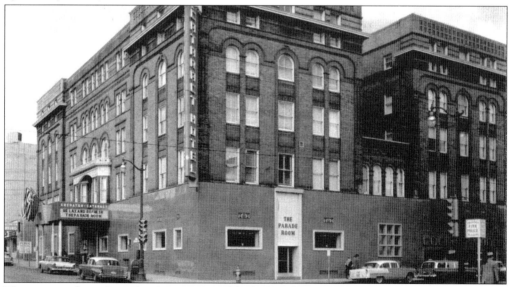

This picture shows how the Cataract Hotel looked in the 1950s. There was a new facade put on the exterior of the first floor in hopes of modernizing the old building. This building met the wrecking ball in 1973, and the location is now used for the Wells Fargo Bank building.

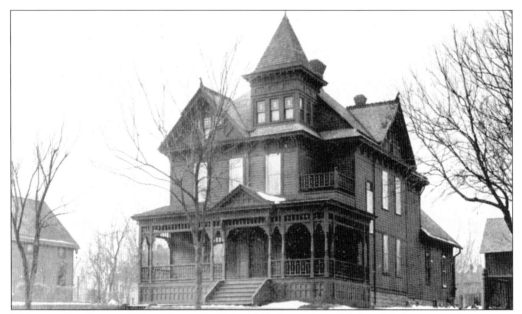

This was the George Abbot House, built in 1887, located at 415 South Minnesota Avenue on the west side between Twelfth and Fourteenth Streets. This was the Abbot family's home until the 1970s, and then it was vacant. Starting in the 1970s and until it was razed for a parking lot for First United Methodist Church, this house was used by the Sioux Falls Jaycee's Organization as a haunted house fund-raiser. People would line up for blocks in order to go through the house of terror during the Halloween season.

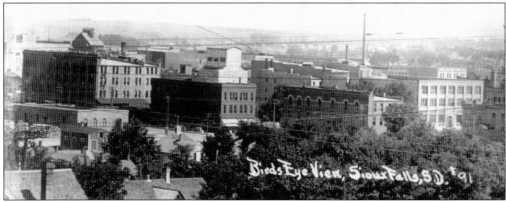

This is a bird's-eye view of downtown Sioux Falls, looking southeast and showing the warehouse district of downtown.

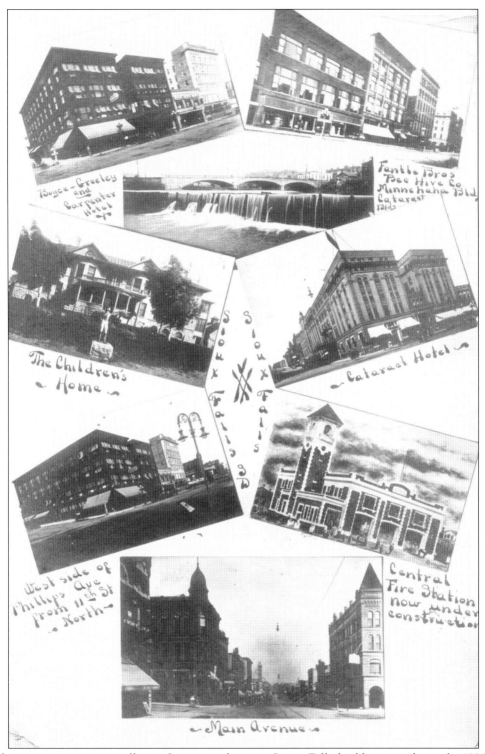

This image is a great collage of pictures showing Sioux Falls buildings in the early 1900s. (Courtesy Mike Wiese.)

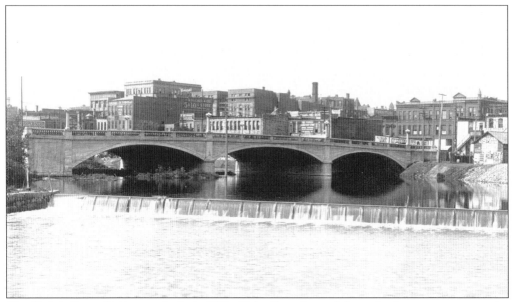

The Eighth Street Bridge was built in 1912. This allowed travel from the downtown area to the east side of Sioux Falls. This view shows the downtown area from the north, near the falls. Some of the buildings in view are, from left to right, Bee Hive Department Store, Edmison-Jamison building, Cataract Hotel, and the VanEps general merchandise and office building.

December 1, 2005, will go down in Sioux Falls history. It was a cold day when the Zip Feed Tower was supposed to come down. The explosives went off, and the building sat down in its hole and did not budge. A wrecking ball had to be brought in to destroy the old Zip Feed Tower. The laughter was almost as loud as the dynamite.

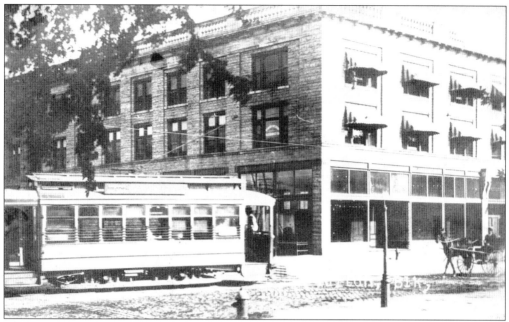

This postcard view shows the use of both the electric streetcar and a horse and buggy. It would not be long before both would be replaced by the automobile. The building in the background was the Paulton building on the southeast corner of Phillips Avenue and Eleventh Street. The Paulton building, later known as the Hanson building, was built in 1906 and burned down in 1991.

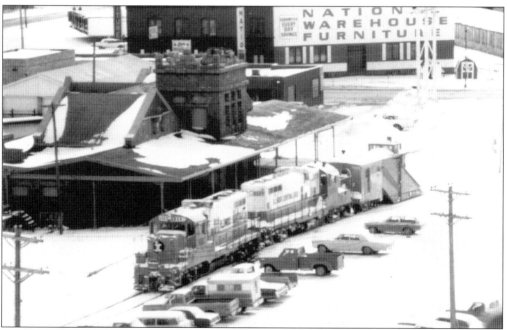

This picture was taken on top of the Raven Industries building in 1975 by Ed Monson. The train with the snowplow was being sent out to open up the line between Sioux Falls and Cherokee. (Courtesy Ed Monson Collection.)

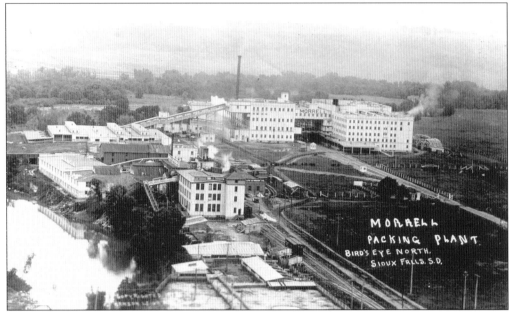

This view shows the John Morrell Meat Packing Plant. At the center of the photograph is the former Sioux Falls Linen Mill and later the Green Meat Packing Plant before finally being taken over by the John Morrell Meat Packing Plant. A closer view is seen in the first picture on page 111.

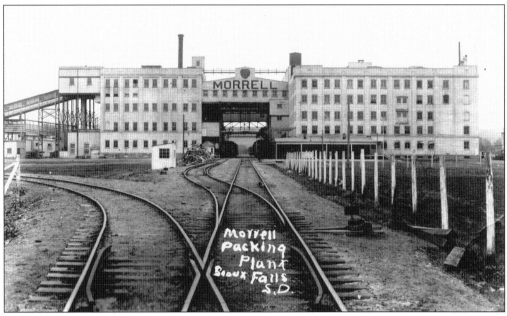

The John Morrell Meat Packing Company was established in 1827 in England. In 1909, the company began operations in Sioux Falls. Today the Sioux Falls plant is the largest of eight USDA-approved meat facilities and produces fresh pork and many processed meats. The John Morrell Meat Packing Company continues to be one of the largest employers in the city.

This building was built in 1891 and was torn down in 1949. The building was built for the Sioux Falls Linen Mill. Later it was used as a pickling works and as the Green Meat Packing Plant, before being taken over by John Morrell Meat Packing Company in 1909. The small building to the right was the Sioux Falls Plow Company. A closer picture is seen in the image below.

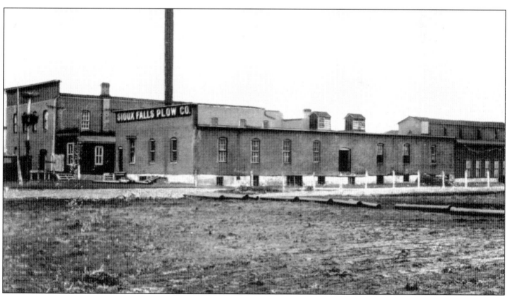

The Sioux Falls Plow Company conducted business in the late 1890s and early 1900s.

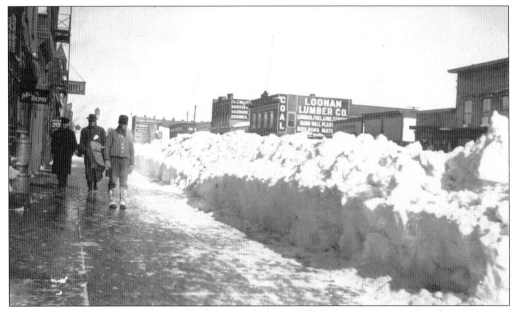

This is a picture of Main Avenue, looking north from Eighth Street. Loonan Lumber Company was located at 220–226 North Main Avenue. This is northeast from what today is the Downtown Siouxland Public Library.

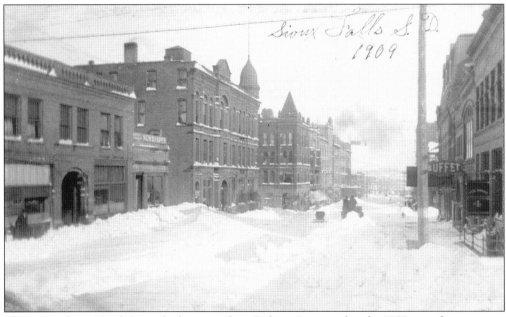

This image shows Ninth Street looking east from Dakota Avenue after the 1909 record snowstorm. Snow had to be shoveled into horse-drawn wagons and removed from the downtown area.

This image is a view of the railroad yards south of Eighth Street. This picture is looking west to downtown. In the lower left of the picture is the Great Northern Railway Depot, which stands today. In the middle of the picture is the Chicago, St. Paul, Minneapolis, and Omaha Railway Company, which was razed. The Wilson Storage and Transfer Company building can also be seen in the middle of the picture. The picture below shows a closer view of the Wilson Storage and Transfer Company building.

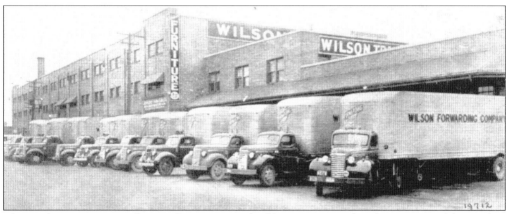

The Wilson Storage and Transfer Company building was completed in 1930 and located at Eighth Street and Reid Avenue next to the railroads for easy access to pick up goods that were brought by train. Today this building was been renovated into the 8th and Railroad Center, which has several shops and office spaces. (Courtesy Mike Wiese.)

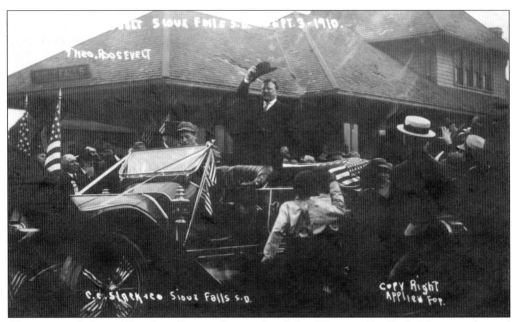

This postcard shows Theodore Roosevelt outside of the Chicago, St. Paul, Minneapolis and Omaha Depot in 1910. Roosevelt became president after the assassination of Pres. William McKinley in 1901. Both Roosevelt and McKinley had Sioux Falls high schools named in their honor. Roosevelt High School began in 1991, on the northeast corner of Forty-first Street and Sertoma Avenue. McKinley High School, located at Eleventh Street and Spring Avenue, was the former Irving High School and eventually became Irving Elementary School. (Courtesy Mike Wiese.)

The USS *South Dakota* Battleship Memorial is located in Sioux Falls. This battleship was commissioned in 1942 and was honored as the most highly decorated battleship in history. Serving proudly during World War II and participating in every major naval battle in the Pacific, this ship earned 14 battle stars before it was decommissioned in 1947.

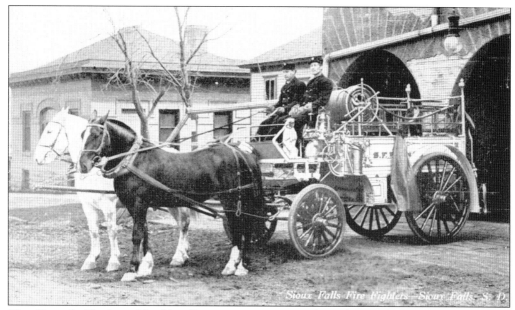

The Cascade Hook and Ladder Company was stationed in the northwest part of the City Auditorium. This new building provided space not only for the firemen but also for the horses and horse-drawn equipment that were required to fight early prairie and structure fires. Up until the fire at the Cataract Hotel, on June 30, 1900, all of the firefighters were volunteers. Due to the complete destruction of the famous Cataract Hotel, located on Ninth Street and Phillips Avenue, the city thought it paramount to establish a fully equipped and full-time paid fire department.

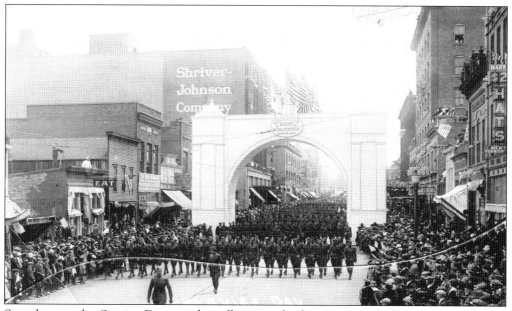

Seen here is the Service Day parade walking north almost to Tenth Street, passing by the Masonic temple. This parade took place on May 21, 1919. Compare this with the picture on the next page.

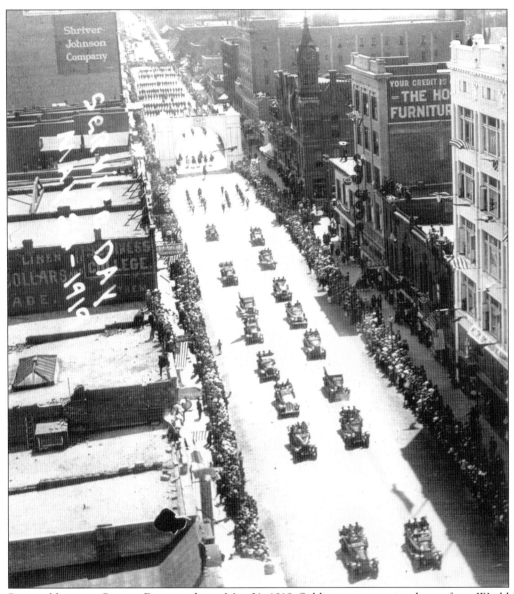

Pictured here is a Service Day parade on May 21, 1919. Soldiers were coming home from World War I. Notice the white arch in front of the Masonic temple. The white building to the right was the new Fantle building, built after a fire had destroyed the previous building a year before.

Here is a parade in front of the Boyce Greeley building. The parade is headed south on Phillips Avenue and is crossing Eleventh Street. Notice that on the back of the wagon there is an advertisement for Ballard and Son Monument Company.

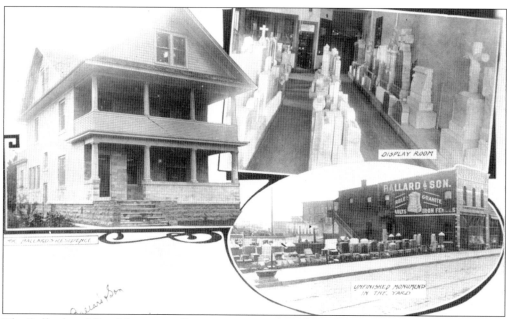

The Ballard and Son Monument Company, pictured on the right, was located on the southeast corner of Main Avenue and Tenth Street. The Ballards' house, pictured on the left, was the first house in Sioux Falls to be built with marble. This house near Fourteenth Street and Minnesota Avenue was recently torn down. The Ballard and Son Monument Company building still stands, and the lettering on the north side can still be seen.

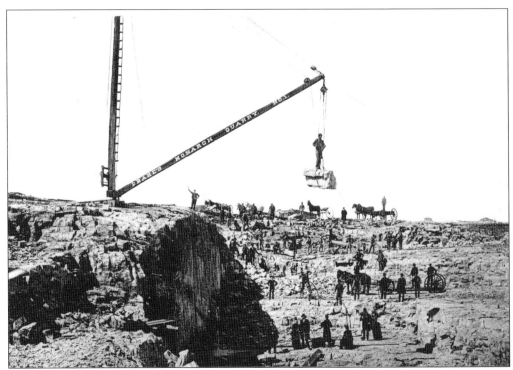

This shows an East Sioux Falls quarry of the Drake's Monarch Quarries. Quartzite was quarried for building and paving stones, sold both locally and to other large cities.

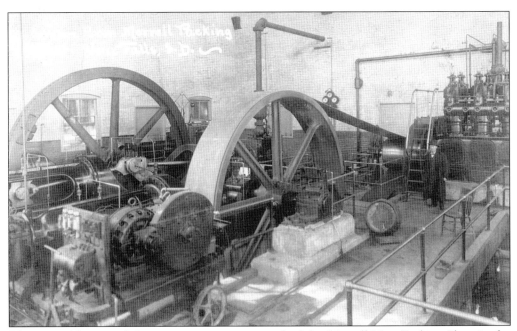

This is an old postcard showing an engine room at the John Morrell Meat Packing Plant in the early 1900s. (Courtesy Mike Wiese.)

Eight

PARKS

The falls of the Sioux River was and still is a favorite recreation area to many Sioux Falls citizens. The falls of the Sioux River have a natural beauty, whether in a dry season with a slow-flowing river or after a heavy summer rain with a fast-flooding river. It is the beautiful rock formations that give this landmark such character. In the past several years, significant improvements have been done to the Falls Park area to improve the once-neglected namesake of this great city.

Seney Island was a 10-acre island located before the falls of the Sioux River. The island extended north to a point near Third Street. This was a main attraction for people coming to the area and was the location of many picnics and other social gatherings. The channel surrounding the island became a dumping site for waste and decreased the beauty and desire for the picnic spot. Later the Milwaukee Railway Company purchased the land and filled in the channel, in order to build on top of what was once the island.

Edwin A. Sherman, nicknamed "the Father of the Park System," helped to establish McKennan Park with an endowment from Helen McKennan. In 1910, he donated the land on which Sherman Park was established in 1913. The Indian Burial Grounds, located within Sherman Park, recognize a people who lived in the area long before Sioux Falls was established.

The city has continued to grow and currently has over 70 parks, which are spread throughout the city. Many of the parks are connected by the bike trail that is more than 14 miles long and goes around the city. The parks today offer everything from a game of horseshoes to a ride on a skateboard ramp. Although different, each park has the same purpose—recreation.

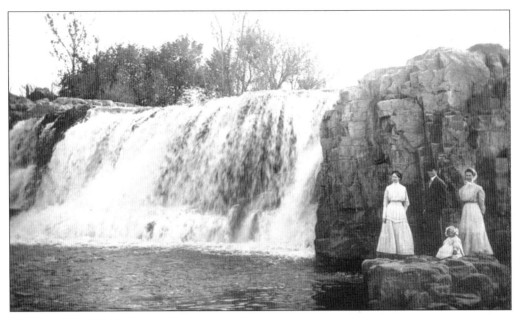

This view shows folks posing for a picture as close as they can get to the largest cascade of the falls. There is no doubt that they could feel the mist from the water of the falls by standing this close. The rock formations continue to attract thousands of people a year to Falls Park.

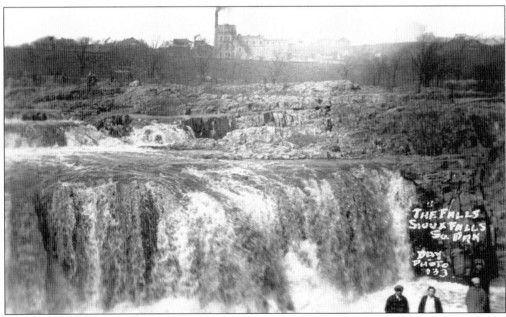

The Sioux River has several cascades, and the water drops nearly 100 feet within a half a mile. The Cascade Milling Company, Queen Bee Milling Company, and the Drake Polishing Works were some of the industries that used these cascades to create energy.

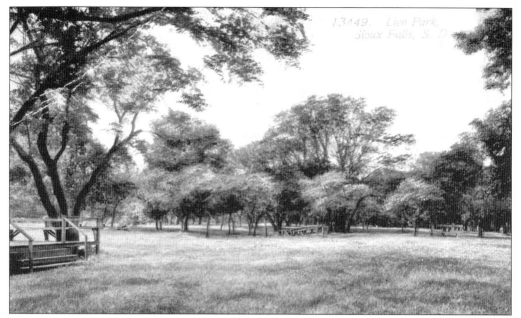

Lien Park was the first official Sioux Falls Park. The land was donated by Burre H. Lien (Sioux Falls mayor 1898–1900) in memory of his brother Jonas H. Lien. Jonas was the first Sioux Falls soldier to lose his life in battle for the United States.

Terrace Park is a beautiful park located by Covell Lake. Fred E. Spellerburg (Spellerburg Park) was instrumental in the development of this park and specifically in the terraces built near where the band shell is located today. The Japanese gardens as they are today were restored from what originally began in 1928. The gardens were damaged due to hostilities toward the Japanese during World War II.

McKennan Park has always been a fascinating place. The park has included the Miniature Village (seen above), sunken gardens, tennis courts, baseball diamond, historic bandshell, horseshoes, and the Pillars of the Nation Monument.

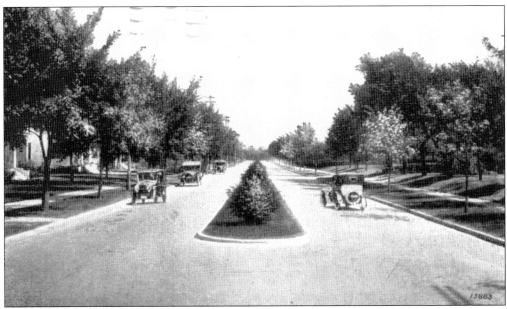

This postcard shows Boulevard Drive, which is Twenty-first Street between Phillips and Seventh Avenues. This is at the north end of McKennan Park. In a way, this street connects the legacy of Helen McKennan by connecting McKennan Park to her hospital, Avera McKennan. At one time, Boulevard Drive marked the edge of the city.

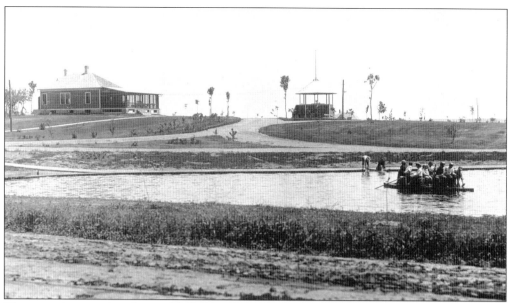

The second city park to be established was McKennan Park located between Twenty-sixth and Twenty-first Streets and Second and Fourth Avenues. McKennan's home, located on the northern edge of the park, and land were generously donated for the city park in 1906. Few trees are in this picture. Today it is the trees that make this park so beautiful. (Courtesy Mike Wiese.)

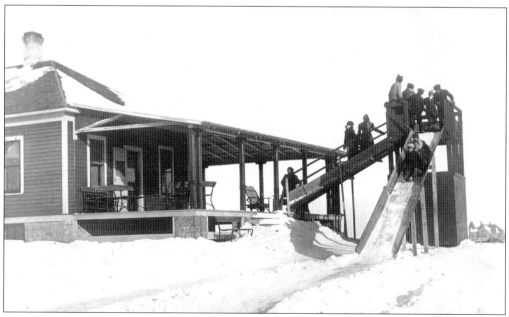

This is a closer view of the park house at McKennan Park. This building can be seen in the above picture on the left side. A slide had to be built in the winter in order to ride a toboggan due to the flatness of the area. McKennan Park still has no hills to allow sledding.

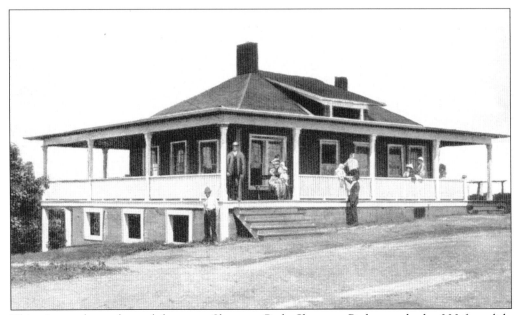

This picture shows the park house at Sherman Park. Sherman Park once had a 300-foot slide that started on the top of the Native American mounds and extended down into the water. There also was an old army tank that was a part of the Dennis the Menace Park, located just south of the zoo complex.

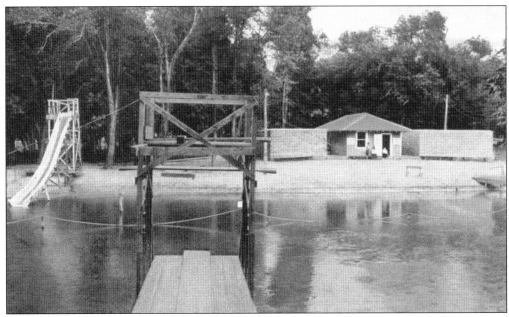

This picture shows the bathing house at the Sherman Park swimming area before any city swimming pools were constructed. The river was dammed up to make an area for swimming and boating. The Drake Springs pool was an early city pool that was constructed in 1934.

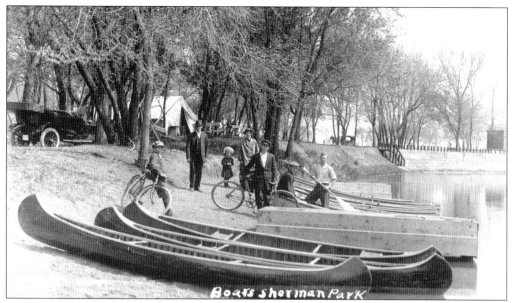

This is an early view of wooden canoes used on the Sioux River. Notice the formal clothes people would wear even when they were boating. This picture is of a bank of the Sioux River at Sherman Park. Sherman Park is the largest park in Sioux Falls.

The river continues to wind through Sherman Park. Early on, the water was dammed up to make a swimming area in about the same area where these boaters were photographed. Today the park includes the Great Plains Zoo and Delbridge Museum, the USS *South Dakota* Battleship Memorial, and many baseball diamonds.

This land, the present-day Covell Lake area, was once owned by the family of Dr. Josiah L. Phillips and purchased by the city in 1916. Hattie Phillips, wife of Dr. Phillips, lived in the mansion on the hill in the center of the picture. A closer view of the house can be seen in the picture below. The building to the left was used to store animals for the early zoo in the 1920s through the 1960s. The lower part of this building still exists.

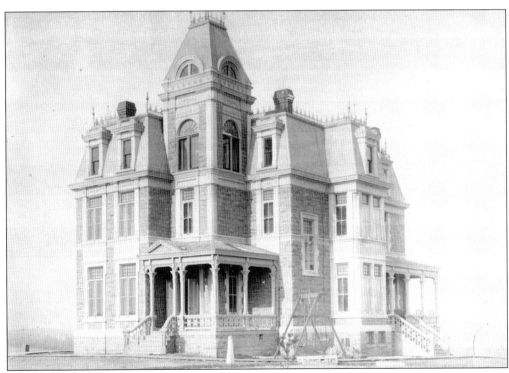

Seen here is the beautiful house of Hattie Phillips, wife of Sioux Falls pioneer Dr. Phillips. This house was perched on top of the hill overlooking Terrace Park and Covell Lake. The house was built in 1885, three years after Dr. Phillips's death. There was a major fire in 1908, but this ornate house was not razed until 1966. (Courtesy Siouxland Heritage Museums, Sioux Falls.)

SIOUX FALLS VILLAGE PRESIDENTS AND CITY MAYORS, 1877–PRESENT

1877–1881	Charles K. Howard	President of Sioux Falls Village
1881–1882	Lyman T. Dunning	President of Sioux Falls Village
1882–1882	T. T. Cochran	President of Sioux Falls Village (died in office)
1882–1885	Jacob Schaetzel Jr.	President to mayor (changed Sioux Falls from a village status to a city)

Sioux Falls Village received a city charter, becoming the City of Sioux Falls, Dakota Territory, on March 3, 1883.

1885–1887	Hiram William Ross	Mayor
1887–1889	John Frances Norton	Mayor
1889–1890	Warner E. Willey	Mayor
1890–1894	Porter Pascal Peck	Mayor
1894–1896	Roy Williams	Mayor
1896–1898	A. H. Stites	Mayor
1898–1900	Burre H. Lien	Mayor
1900–1906	George W. Burnside	Mayor (longest time as mayor, with three terms and 26 years total)
1906–1908	Frank W. Pillsbury	Mayor
1908–1909	W. T. Doolittle	Mayor
1909–1924	George W. Burnside	Mayor
1924–1929	Thomas M. McKinnon	Mayor
1929–1934	George W. Burnside	Mayor
1934–1939	Adolph Nelson Graff	Mayor
1939–1942	John T. McKee	Mayor (died in office on August 31, 1942)
1942	Joseph S. Nelson	Acting mayor after McKee's death until new election
1942–1949	C. M. Whitfield	Mayor
1949–1954	Henry B. Saure	Mayor
1954–1961	Fay Wheeldon	Mayor
1961–1967	V. L. Cruisenberry	Mayor (died in office on December 12, 1967)
1967–1968	Earl McCart	Mayor
1968–1974	M. E. Schirmer	Mayor
1974–1984	R. W. Knobe	Mayor
1984–1986	Joe Cooper	Mayor
1986–1994	Jack White	Mayor
1994–2002	Gary Hanson	Mayor
2002–present	Dave Munson	Mayor

Across America, People are Discovering Something Wonderful. Their Heritage.

Arcadia Publishing is the leading local history publisher in the United States. With more than 3,000 titles in print and hundreds of new titles released every year, Arcadia has extensive specialized experience chronicling the history of communities and celebrating America's hidden stories, bringing to life the people, places, and events from the past. To discover the history of other communities across the nation, please visit:

www.arcadiapublishing.com

Customized search tools allow you to find regional history books about the town where you grew up, the cities where your friends and family live, the town where your parents met, or even that retirement spot you've been dreaming about.